Provincetown
PERSPECTIVES

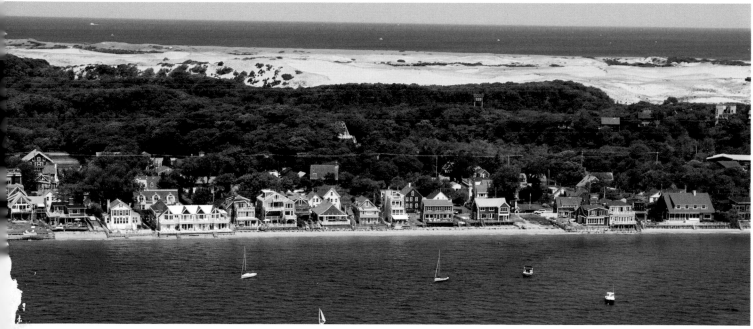

Text & Photography by Arthur P. Richmond

Schiffer Publishing Ltd®

30 Lower Valley Road Atglen, Pennsylvania 19310

Contents

Title page: Houses line Commercial Street in the East End. In the dunes beyond are the hidden shacks.

Published by Schiffer Publishing Ltd.
4880 Lower Valley Road
Atglen, PA 19310
Phone: (610) 593-1777;
Fax: (610) 593-2002
E-mail: Info@schifferbooks.com
For the largest selection of fine reference books on this and related subjects, please visit our web site at **www.schifferbooks.com**
We are always looking for people to write books on new and related subjects. If you have an idea for a book please contact us at the above address.

This book may be purchased from the publisher.Include $3.95 for shipping. Please try your bookstore first. You may write for a free catalog.

In Europe, Schiffer books are distributed by
Bushwood Books
6 Marksbury Ave.
Kew Gardens
Surrey TW9 4JF England
Phone: 44 (0) 20 8392-8585;
Fax: 44 (0) 20 8392-9876
E-mail: info@bushwoodbooks.co.uk

Copyright © 2008 by Arthur P. Richmond
Library of Congress Control Number: 2008922197

Designed by Stephanie Daugherty
Type set in Lucia BT/Zurich BT
ISBN: 978-0-7643-2959-3
Printed in China

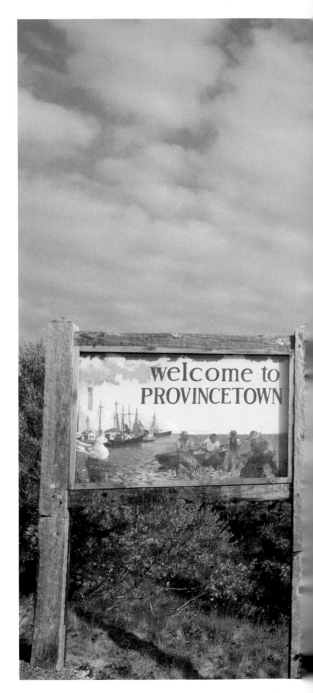

Introduction

Welcome to Provincetown at the tip of Cape Cod, a mélange of New York's Greenwich Village and Florida's Key West. A tourist destination for over 100 years, this seaside village has attracted artists, authors, and nature lovers for the beauty, solitude, and ephemeral light present here. Only about 50 miles by water and a little more than 100 miles by road from Boston, P'town, as it's known locally, is a popular destination for worldwide visitors; during the summer, sightseers flock to its many attractions.

Historically, there have been several significant dates and events in Provincetown's storied past. Leif Erickson's brother Thorvald may have visited as early as 1004 A.D. Six hundred years later, Bartholomew Gosnold visited the area in 1602 and named it Cape Cod for the abundance of cod fish. After mooring in P'town harbor for a short time, he traveled to Cuttyhunk, the last of the Elizabeth Islands, a chain southwest of Woods Hole in Falmouth. There he tried to establish a colony, but, since not enough passengers wanted to stay, they sailed back to England.

The most famous visitors to sail into P'town harbor were the Pilgrims, who arrived on the *Mayflower* on November 21, 1620, and stayed for 5 weeks before moving on to Plymouth. Four members of the original crew and passengers are buried in the Old Town cemetery. Realizing the need for rules and some form of control, the Pilgrims drafted and signed the Mayflower Compact, which is considered to be the democratic basis of the United States and a precursor of our Constitution. More information and documentation can be found in Bradford Park and at the museum at the Pilgrim Monument.

Originally part of Truro, Provincetown was incorporated as a town in 1727 and named after the state owned Province Lands, still used as a designation by the Cape Cod National Seashore.

Left: A welcome sign on Route 6 is the first indication that visitors have reached their destination. In the background is Pilgrim Lake in front of the parabolic dunes.

P'town is famous for its treacherous offshore waters that have claimed numerous ships; in 1778, during the Revolutionary War, the 64 gun British frigate *Somerset* floundered and came aground about 2 miles from Race Point. The captain and crew were captured and marched to Boston.

Provincetown is the oldest continuously active art colony in America, beginning in 1899 when Charles Hawthorne opened his Cape Cod School of Art. Famous for its exceptional light, the area drew artists who painted the local scenes; many would become icons in American art. In 1914, Hawthorne was also instrumental in establishing the Provincetown Art Association and Museum, which has grown to become a well-respected institution, with a collection of almost 2,000 works by Outer Cape artists and artisans.

In 1961, the Cape Cod National Seashore was established, preserving 44,000 acres from Chatham to Provincetown for future generations. Shifting dunes, beautiful beaches, and bike and hiking trails are all part of the attraction of the Province Lands.

Now P'town is a destination focal point for thousands, as its beaches, galleries, and restaurants are rated as some of the best in the country. Inclusiveness and diversity attract numerous gays and lesbians.

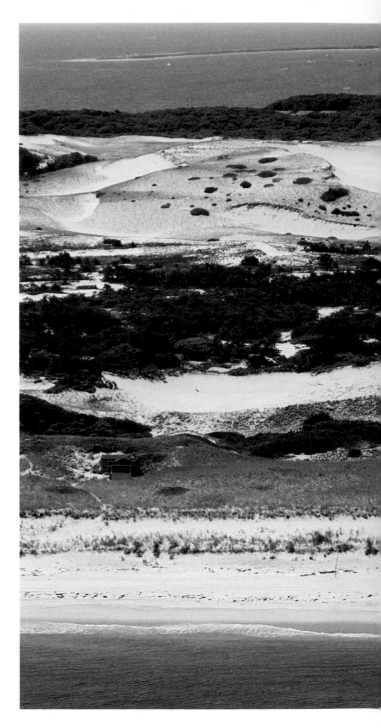

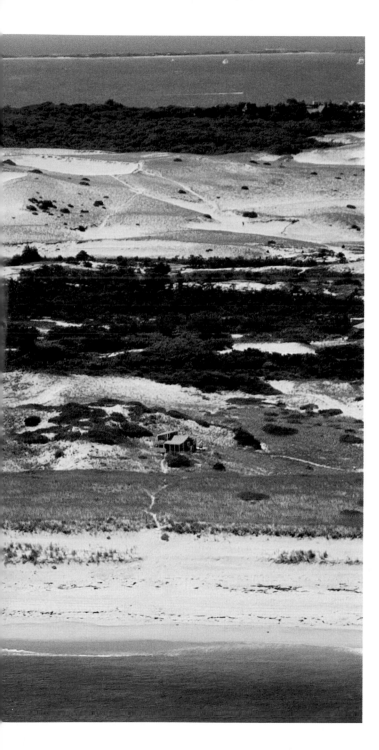

Provincetown from the Air

One of the best ways to see Provincetown is from a sightseeing flight that circles the tip of Cape Cod. On a clear day, it is possible to put this fragile ever-changing landscape in perspective, as it juts into the ocean. One can see Plymouth and Duxbury across the bay to the west, and the Sandwich tower near the canal to the southwest, while breathtaking views of Truro, Wellfleet, and Eastham can be seen to the south.

The following images make a loop around the tip of Cape Cod, starting on the Atlantic Ocean side near Truro, moving north along the outer beach past the three outermost lighthouses (all active aids to navigation), and ending with several views of Provincetown's inner harbor. Since the land is such a narrow strip, both the Atlantic Ocean and Massachusetts Bay are visible in most of these vistas.

Hidden and isolated in the dunes are 17 shacks with limited amenities that can only be reached with a 4 wheel drive vehicle. Authors, artists, and innovative individuals have sought the solitude of these places to create and express their vision. Behind the trees in the near background, is the east end of Commercial Street,, and the thin strip of land in the distance terminates at Long Point.

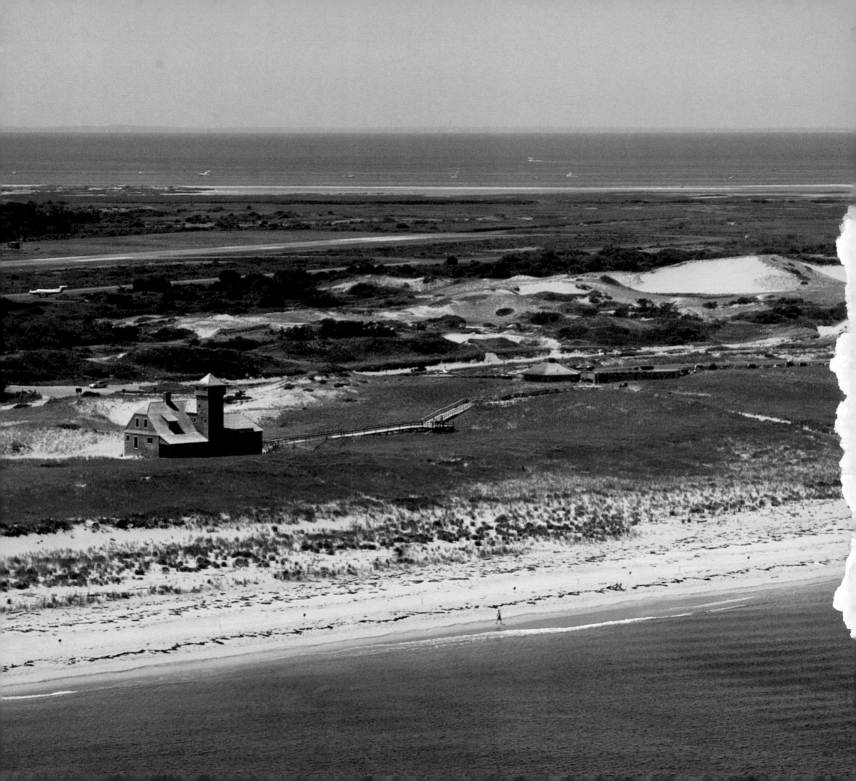

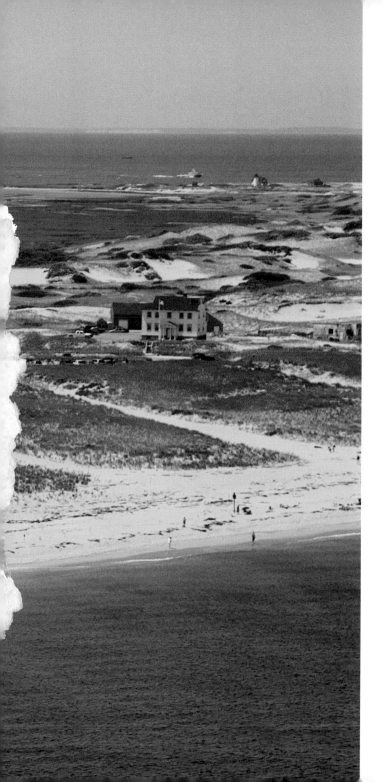

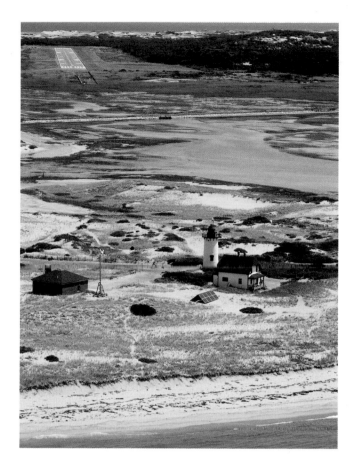

Left: Further north, at the beginning of Race Point beach, the Old Harbor Lifesaving Station is to the left, and the National Seashore Ranger Station is the white building with the red roof to the right.

Above: Race Point Lighthouse is the most northern active aid to navigation on Cape Cod. Hatches Harbor in the background is part of a restoration project to return the area to its natural condition. The single runway Provincetown Airport can be seen in the distance.

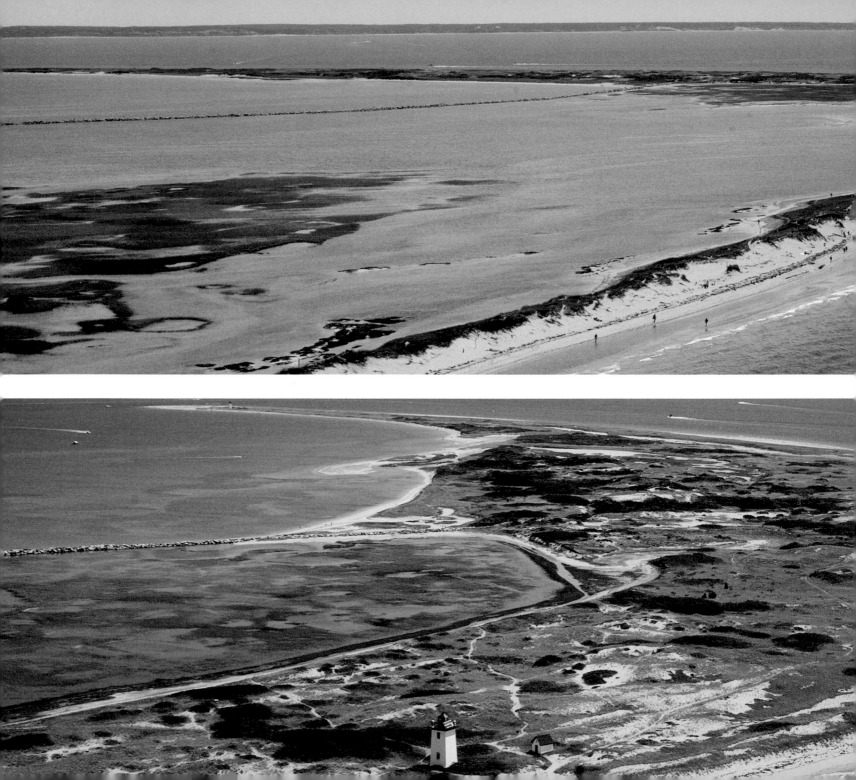

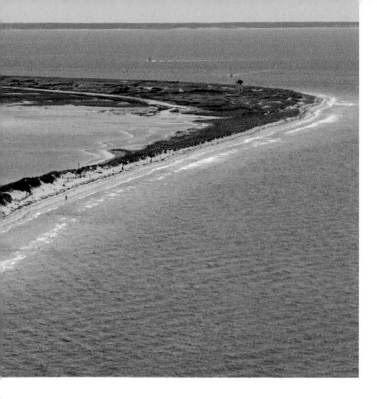

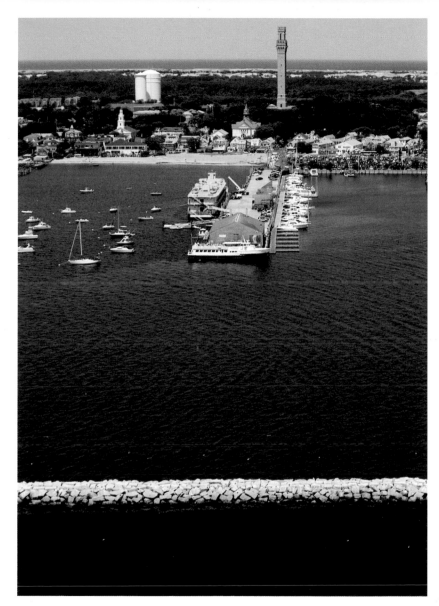

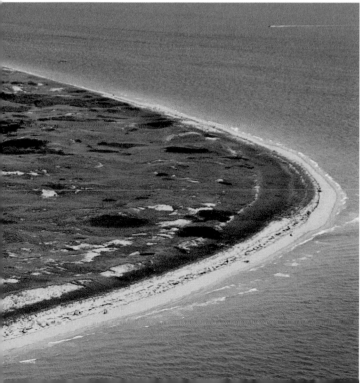

Top left: Herring Cove Beach is a thin barrier extending into the distance. The walking dike can be seen on the left.

Bottom left: The second lighthouse guiding mariners into the harbor is Wood End, which can be seen in the foreground. The tip of the cape is in the distance with Truro beyond the bay.

Above: The center of P'town with Macmillan wharf on the left. Along the skyline, right to left, the Pilgrim Monument, Town Hall and the Universalist Meeting House are visible.

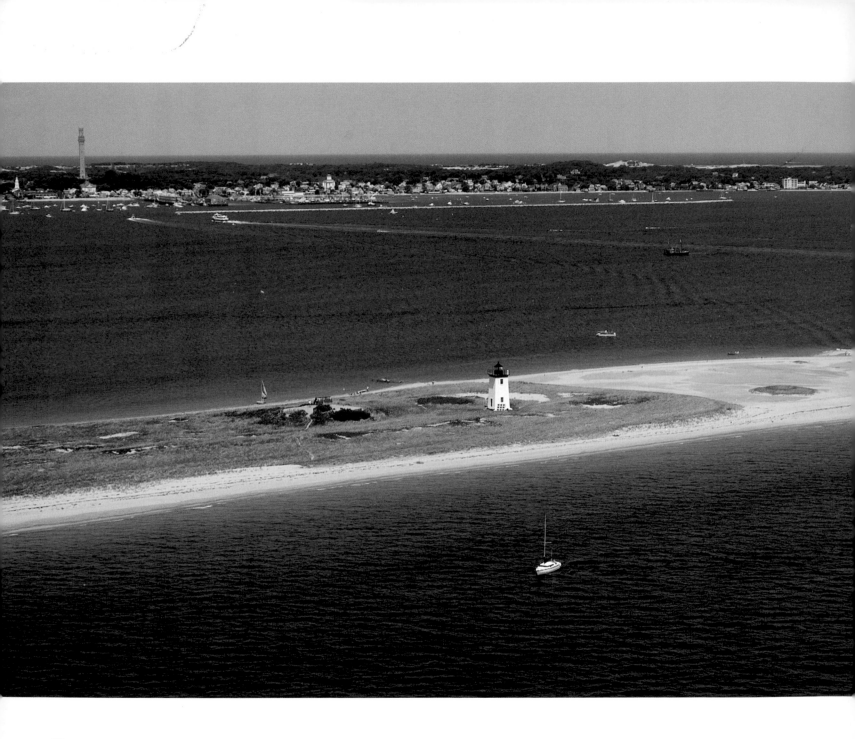

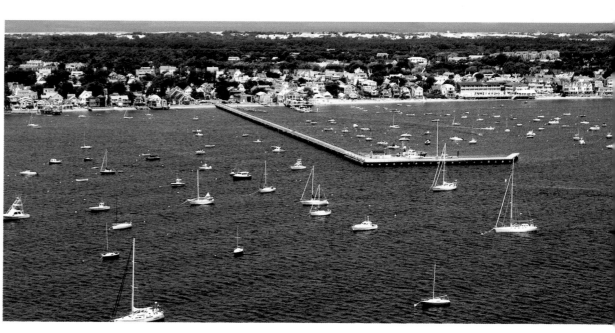

Left: Long Point Lighthouse, standing at the end of the cape, is all that remains of a once active fishing village.

Above: The west end of Commercial Street with the distinctive Coast Guard pier.

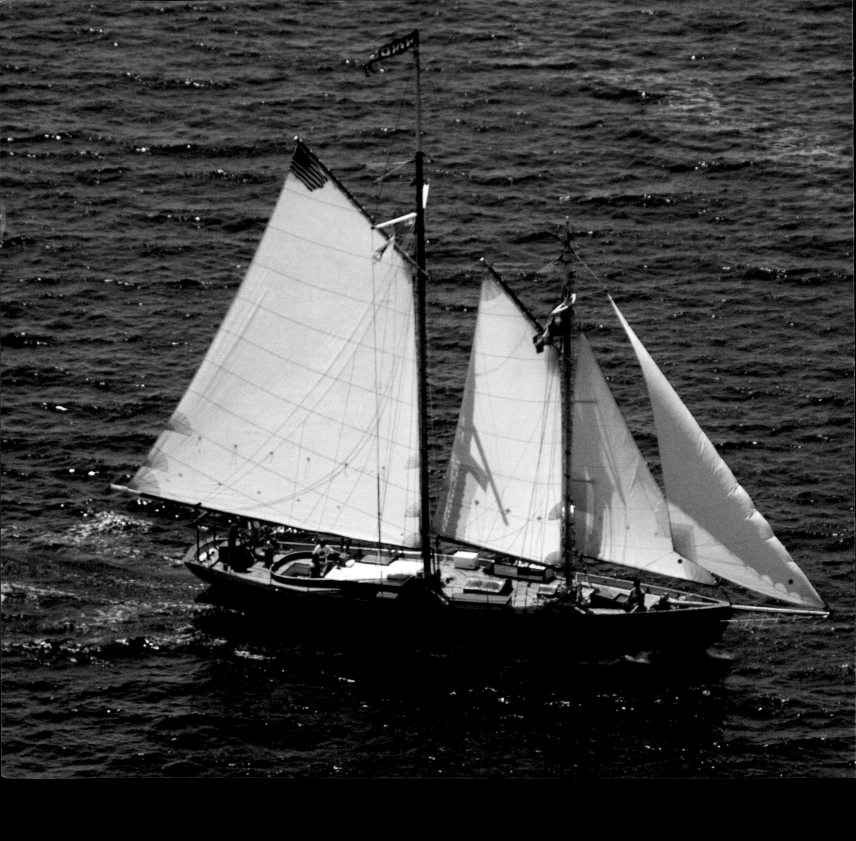

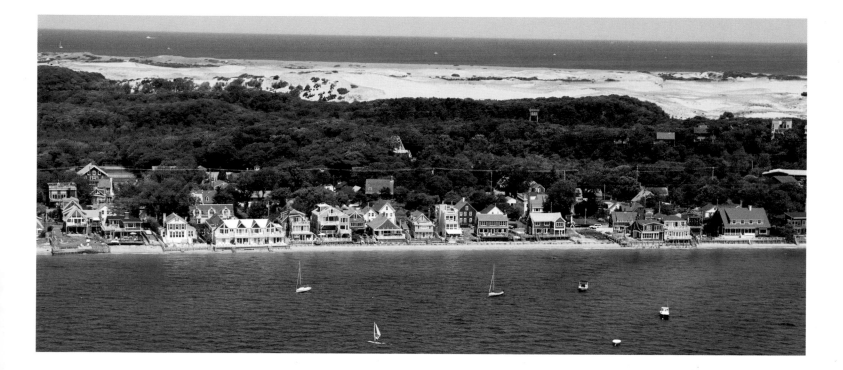

Left: For a quiet, peaceful way to see the bay, several sailing craft cruise from P'town. Seen here is the schooner *Hindu*, which is over 80 years old and has been taking passengers around the harbor for over 60 years.

Above: Houses line Commercial Street in the East End. In the dunes beyond are the hidden shacks.

Pilgrim Monument

At 252 feet tall, the Pilgrim Monument, located on High Pole Hill, is the most dominating structure on the Outer Cape. This landmark can be seen for miles and is an important visual reference for navigators. Built to commemorate the 1620 landing of the Pilgrims, Monument construction began in 1907 when President Theodore Roosevelt laid the cornerstone. In 1910 President William Howard Taft dedicated the tower, which is the tallest granite structure in the United States. Within the tower, individual blocks representing Massachusetts cities and towns can be found on the wall, as one climbs the circular staircase to the top. Also on the grounds is a museum with displays that educate the public about Provincetown's history. One of the best ways to see the town and outer cape is to climb the tower and experience the 360 degree views.

PILGRIM MONUMENT AND PROVINCETOWN MUSEUM

Based on the Torre del Mangia in Siena, Italy, and designed by Willard T. Sears, this is the west facing side of the tower.

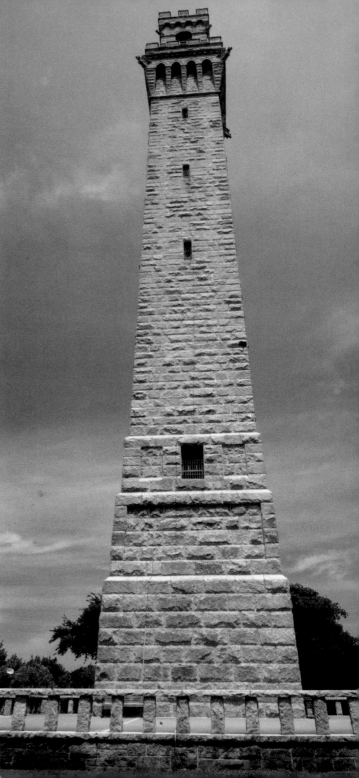

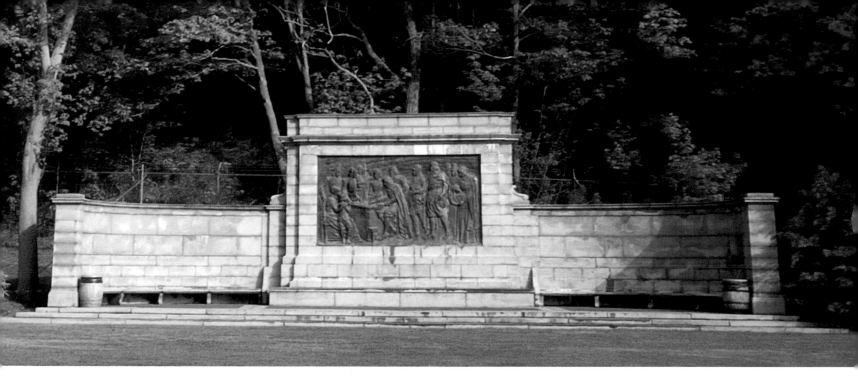

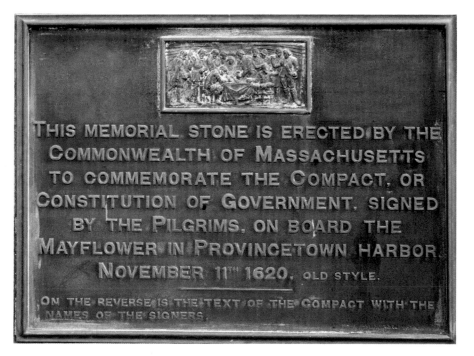

THIS MEMORIAL STONE IS ERECTED BY THE COMMONWEALTH OF MASSACHUSETTS TO COMMEMORATE THE COMPACT, OR CONSTITUTION OF GOVERNMENT, SIGNED BY THE PILGRIMS, ON BOARD THE MAYFLOWER IN PROVINCETOWN HARBOR, NOVEMBER 11ᵀᴴ 1620, OLD STYLE.

ON THE REVERSE IS THE TEXT OF THE COMPACT WITH THE NAMES OF THE SIGNERS.

Bradford Park at the base of the monument is dedicated to the pilgrims and has several interesting plaques. While in Provincetown Harbor, the Pilgrims signed the Mayflower Compact, the precursor to the American Constitution. It can rightly be stated that America had its beginnings in Provincetown Harbor.

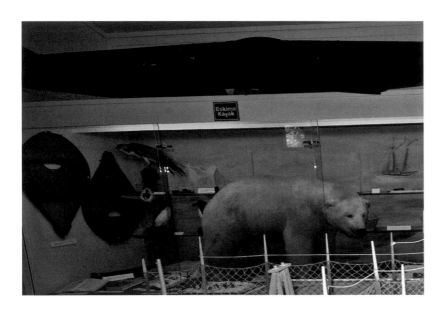

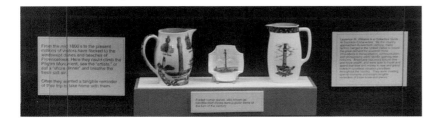

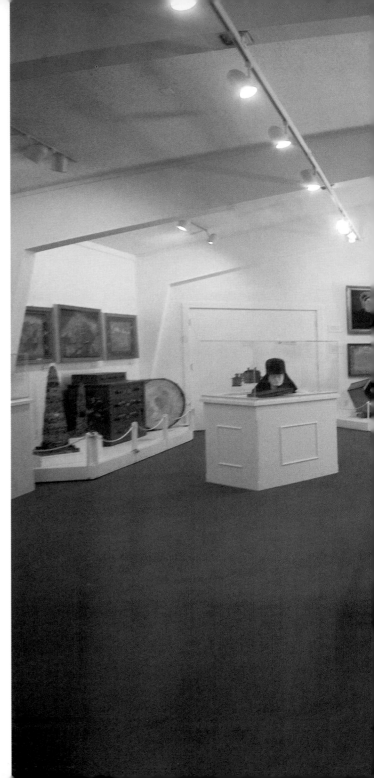

Top: This exhibit in the foreground shows how fish could be caught in traps that would line the shores along the bay. In the background is part of Donald Baxter Macmillan's collection from his exploration of the arctic with Robert E. Peary.

Above: Many commemorative items were produced when the Pilgrim Monument was constructed.

Right: One of the exhibit halls within the museum has an interesting collection of memorabilia.

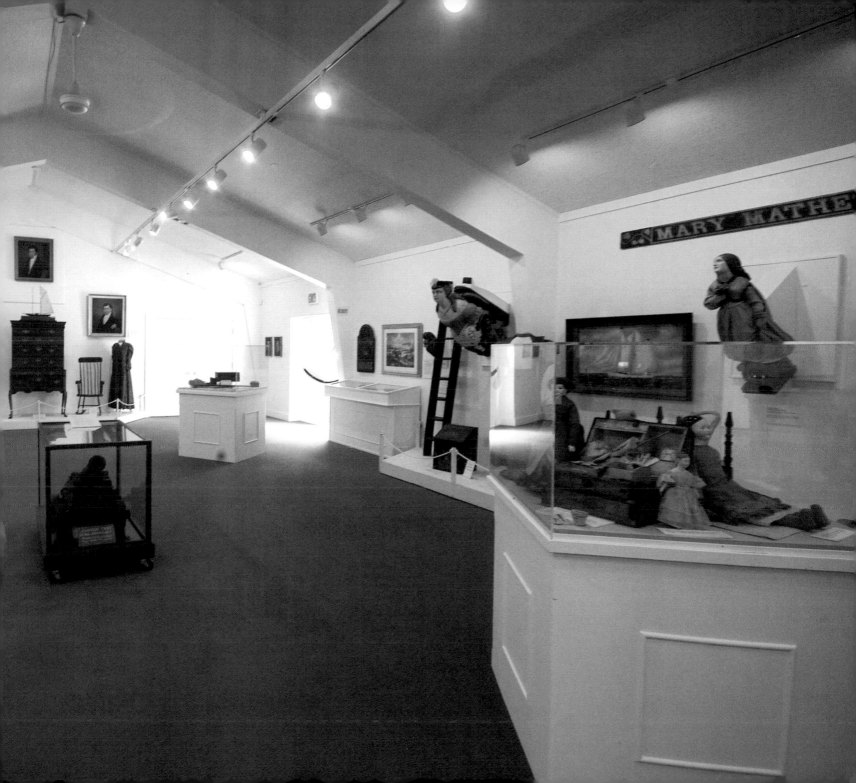

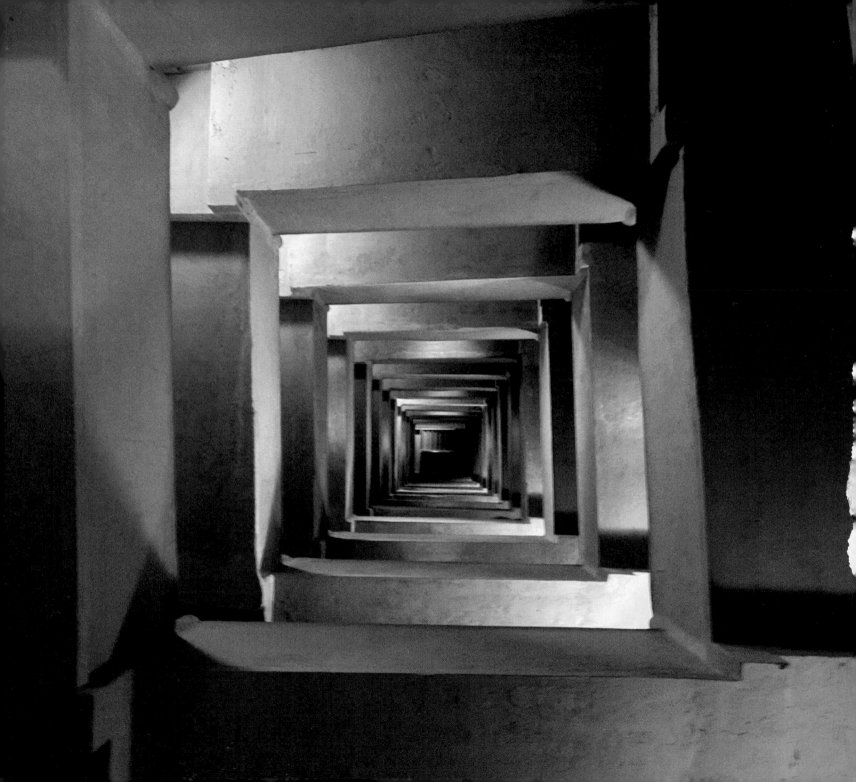

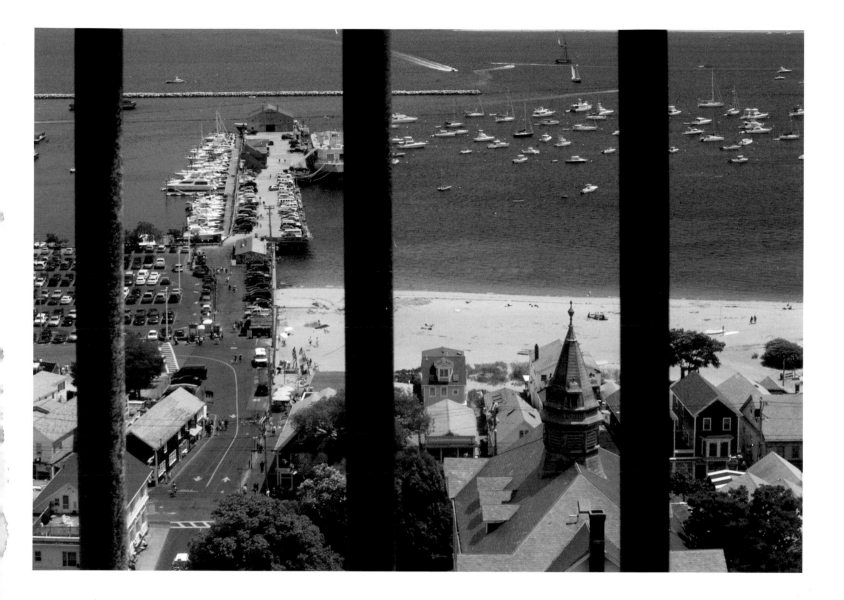

Left: The inside of the tower looking towards the top. Sixty gentle inclines and 116 steps allow the visitor to reach the highest point on Cape Cod.

Above: Looking south through the bars from the top of the Monument, one can see Town Hall in the foreground with the harbor beyond.

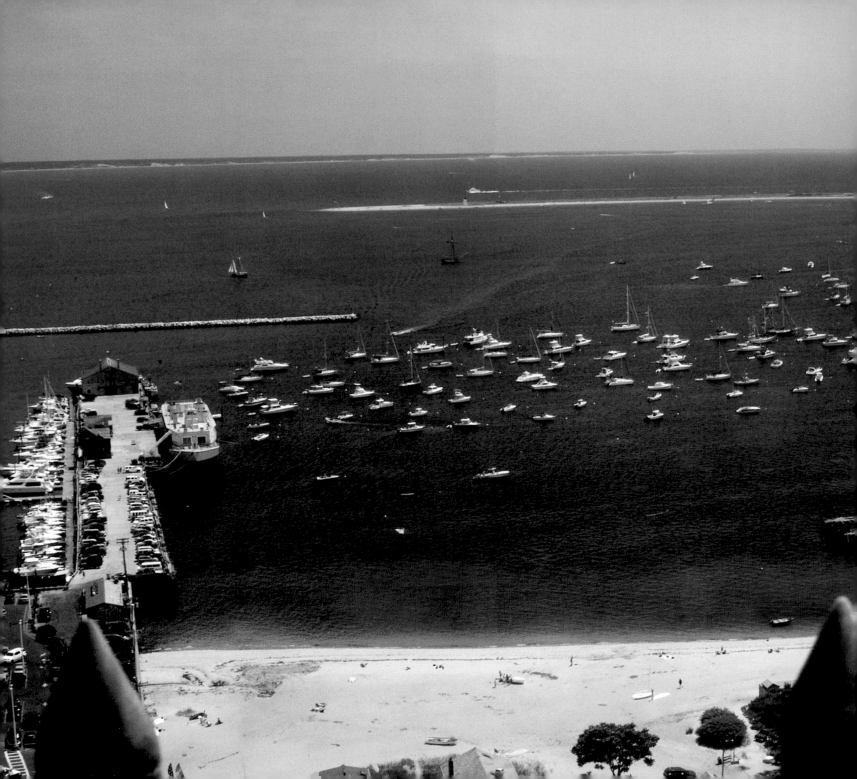

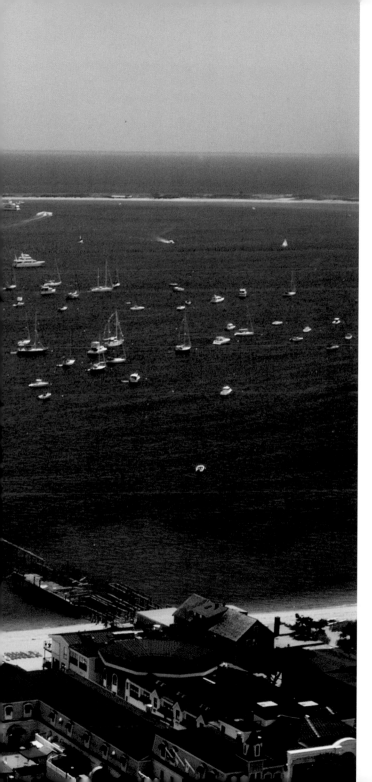

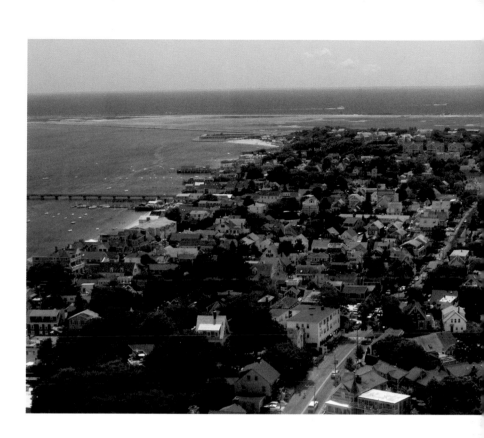

Left: In this view towards the south, Provincetown Harbor is protected by the spit of land in the distance that ends at Long Point.

Above: Looking west towards Wood End lighthouse (at the very left edge of the picture) and Cape Cod Bay. The Coast Guard pier can be seen on the near left.

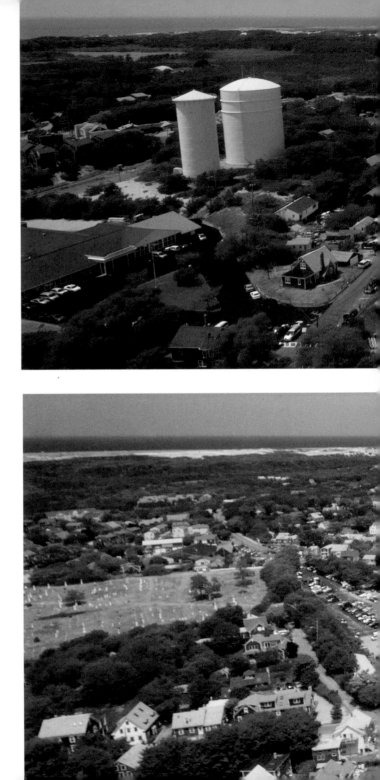

Looking north towards Race Point Beach and the Atlantic Ocean.

Still from the top of the monument, looking east towards Truro.

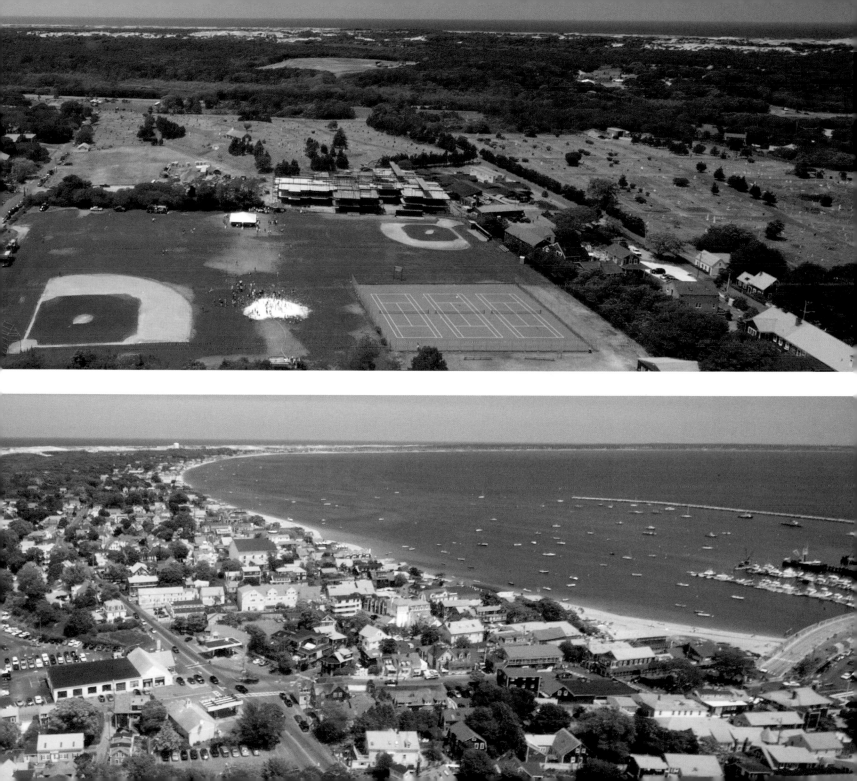

Commercial Street

Commercial Street is a three mile long, one way road that extends from the East End, closest to Truro, through the center of town to the West End and the beginning of Route 6. The first road in Provincetown was the beach, and as all houses faced the water and everybody had some kind of vessel, there was no need for a street. In 1835, when it became necessary for a road to be built, Front Street, later changed to Commercial Street, was constructed. It was 22 feet wide, just as it is today. For about a mile in the middle, shops, galleries, boutiques, restaurants, and nightclubs are the focal points, an activity center for thousands of tourists and visitors. Part quaint fishing village, part bustling art community, and part a place of magic and escape, Provincetown has something to offer a wide diversity of individuals.

Below: At the yellow blinking light on Route 6A, bear left for the start of Commercial Street.

Right: Just beyond the homes on Commercial St., Cape Cod Bay at low tide provides a place to sit and relax.

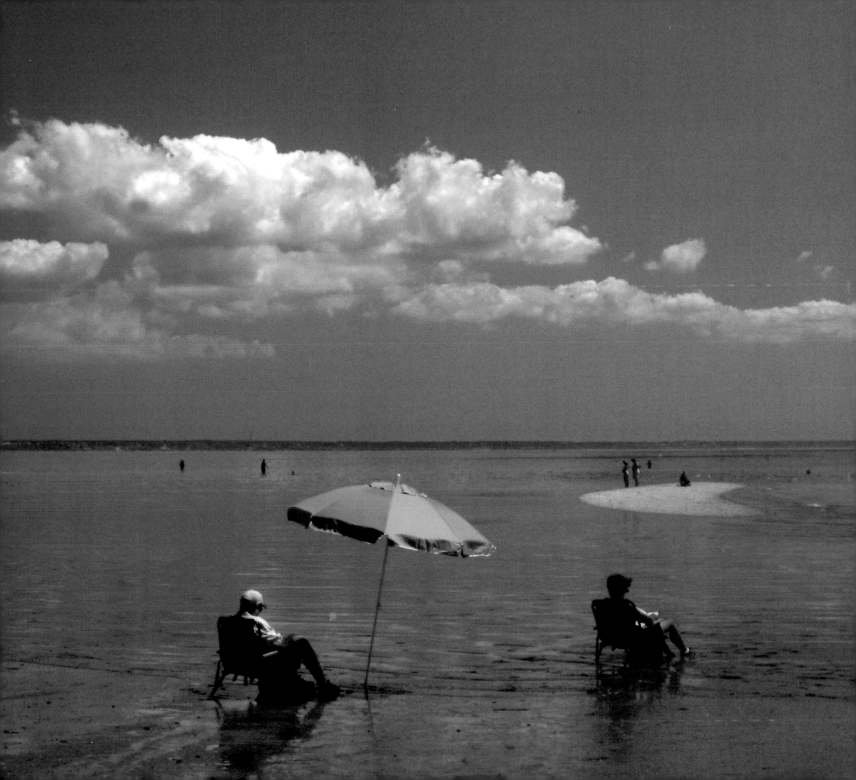

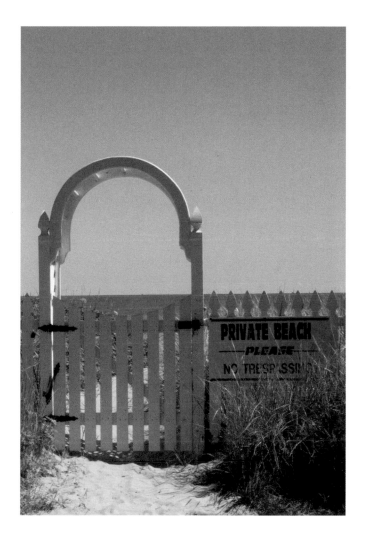

With only one row of homes between Commercial Street and the bay, driveways and walkways lined with flowers offer-charming vistas.

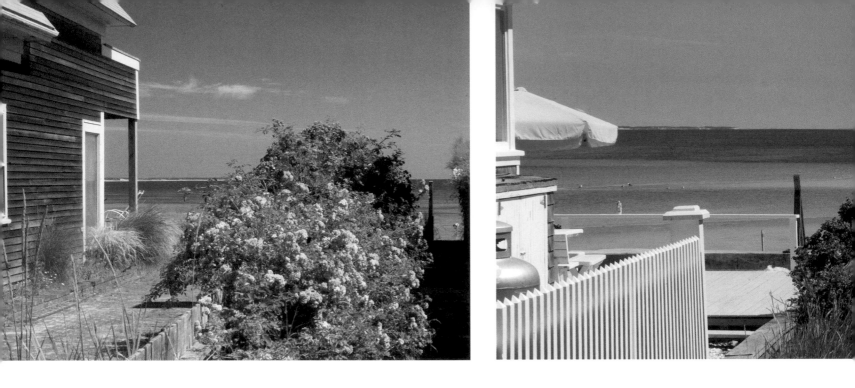

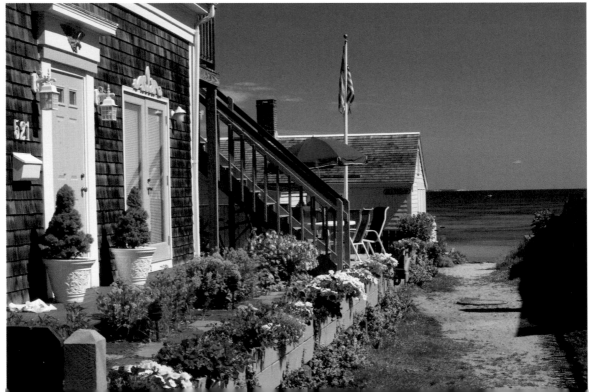

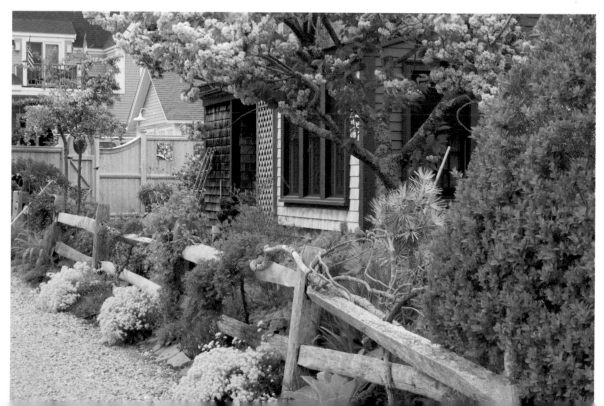

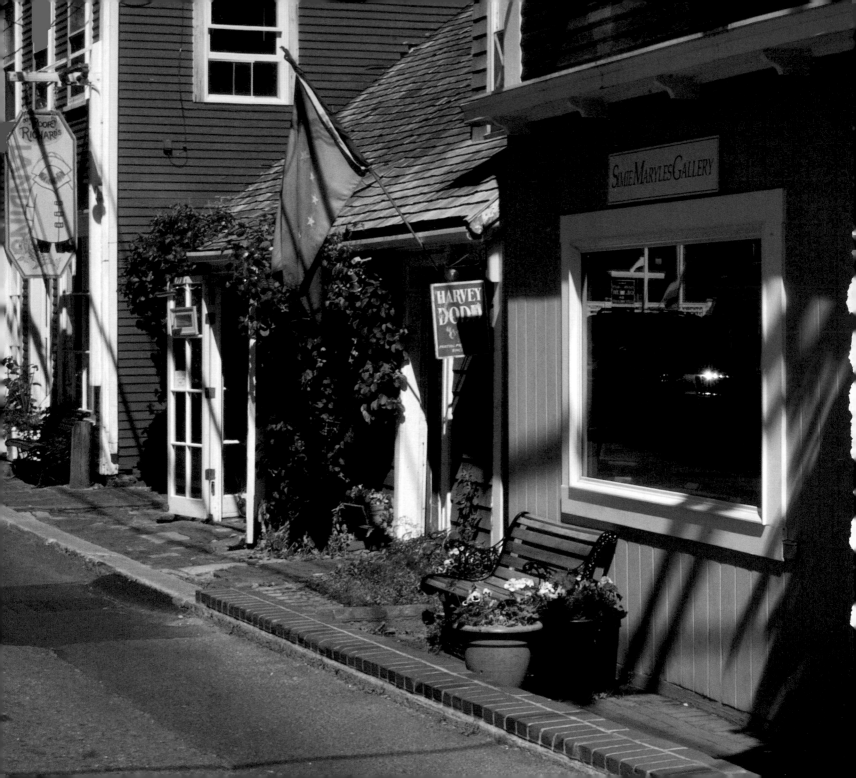

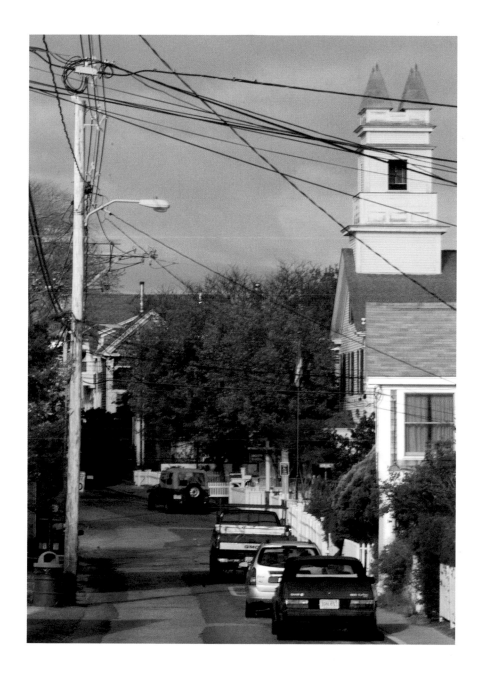

Shops and galleries line Commercial Street.
One way to see P-town is on a trolley tour.
Commercial Street, looking towards the center of town.

PAAM

PROVINCETOWN ART
ASSOCIATION AND MUSEUM

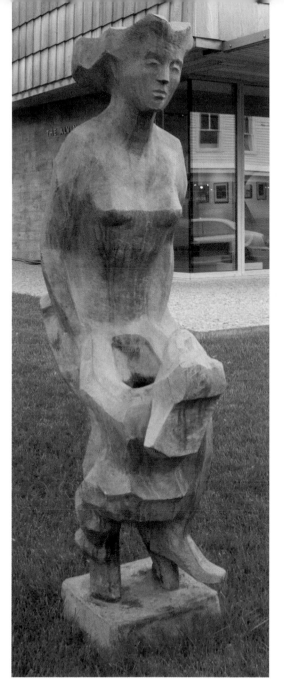

The Provincetown Art Association and Museum at 460 Commercial Street strives to promote and cultivate fine arts with exhibits, concerts, and similar activities.

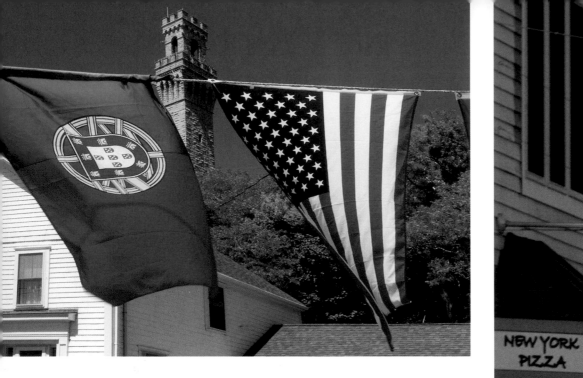

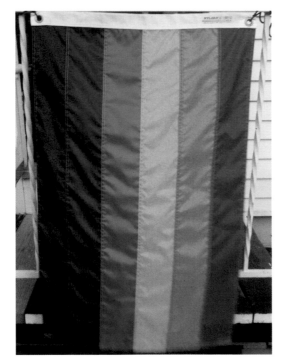

Above:
Portuguese and American flags fly, with the Pilgrim Monument in the background.

Near right:
The gay pride flag is found throughout the town and is displayed as a sign of diversity and inclusiveness.

Visitors stroll along the center of town during the busy summer season.

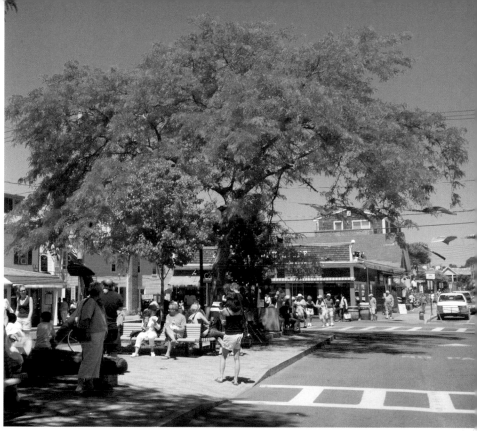

Commercial Street with the Universalist Meeting House in the background on a quiet spring morning.

Manuel E. Lopes Square provides an area to relax in the center of town with Commercial Street in the background. Macmillan Wharf is directly behind this view.

Kids play on an old sailing ship anchor in the square.

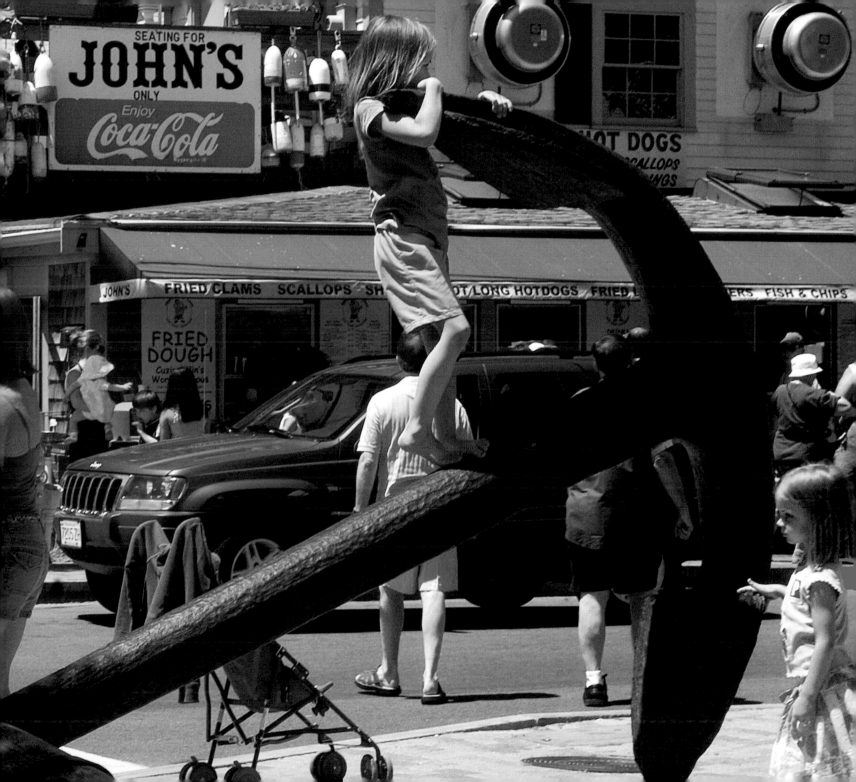

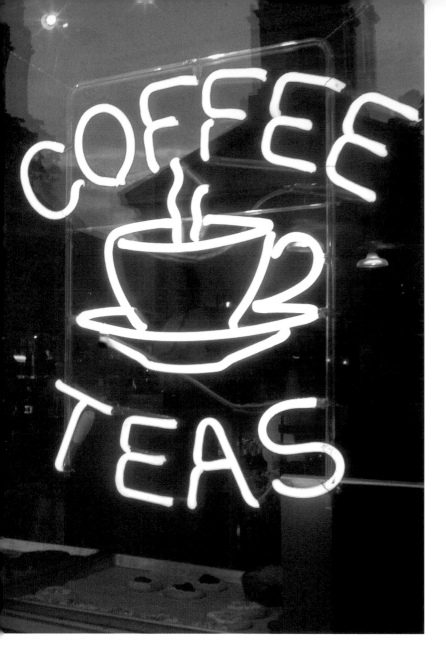

Bright signs offer many varieties of food as well as numerous
establishments offering a diversity of selections from snacks and desserts
to fine dining at highly rated restaurants.

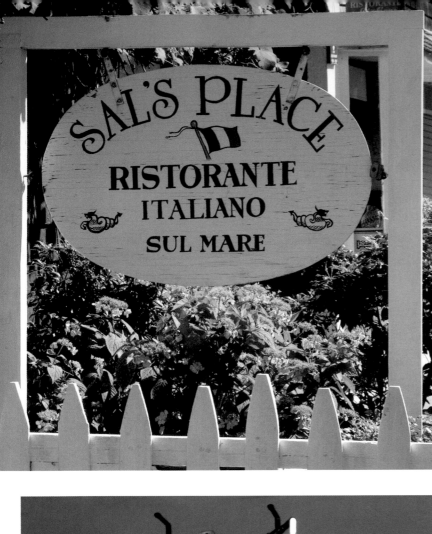

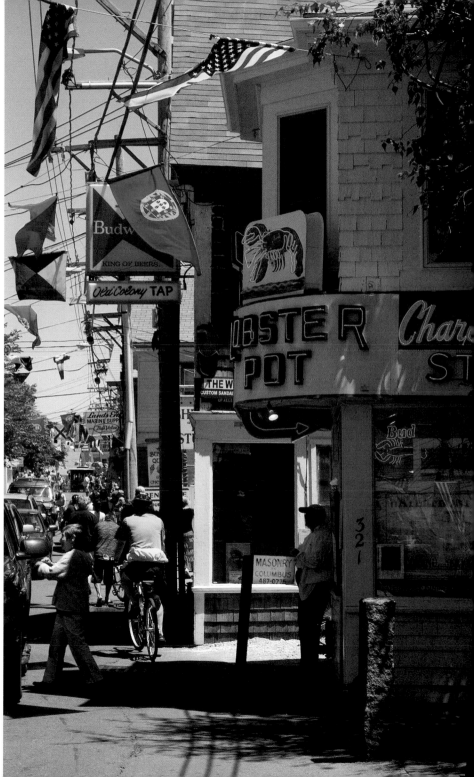

Galleries and boutiques present endless opportunities to shop for a variety of world class items. Narrow lanes lead to unique shops for the discriminating customer.

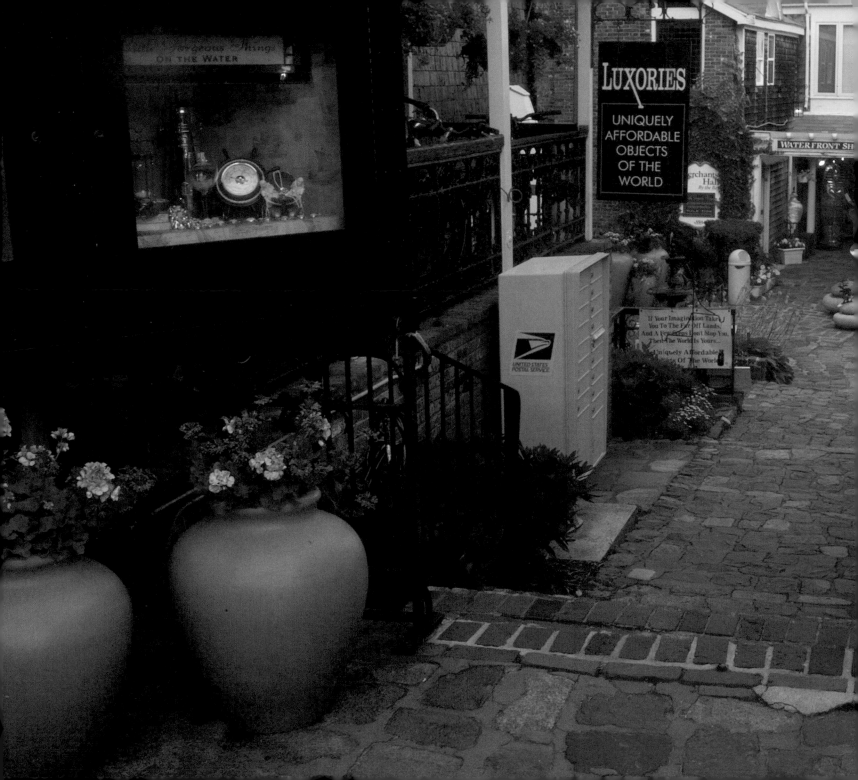

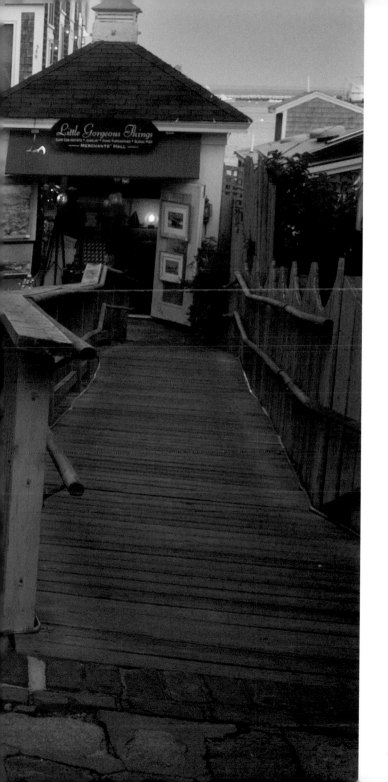

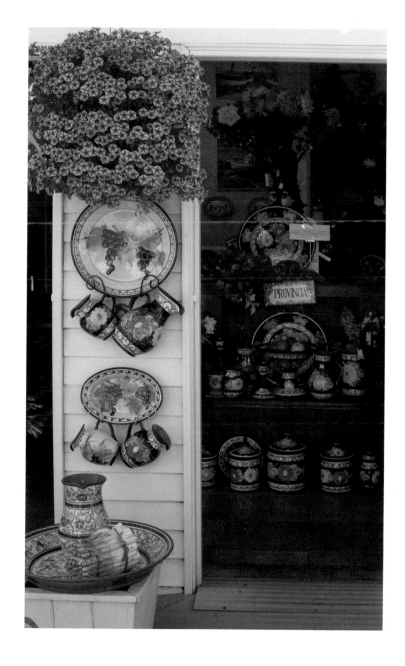

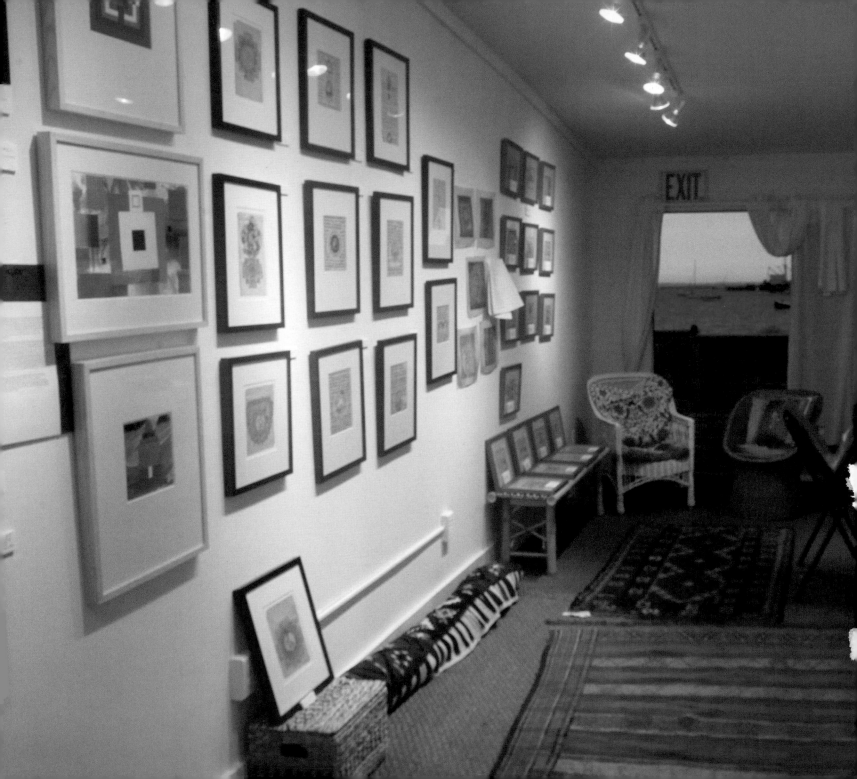

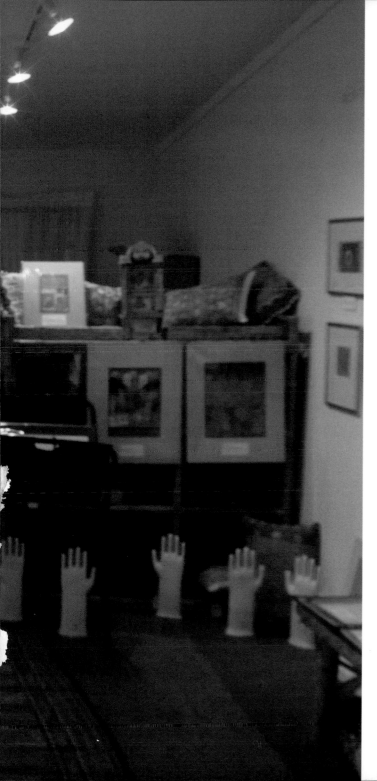

Billboards advertise the latest diversity of shows available. There is usually something available for everybody's taste. Street performers (below) can frequently be found during the active evening hours. Whaler's Wharf is a collection of distinctive shops.

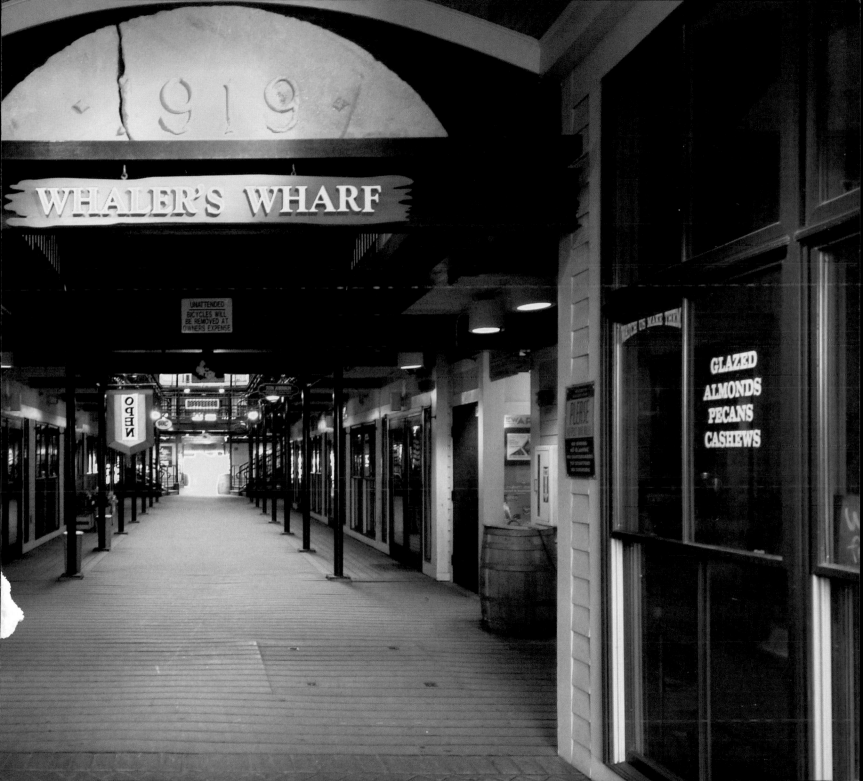

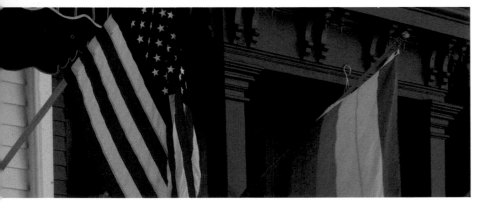

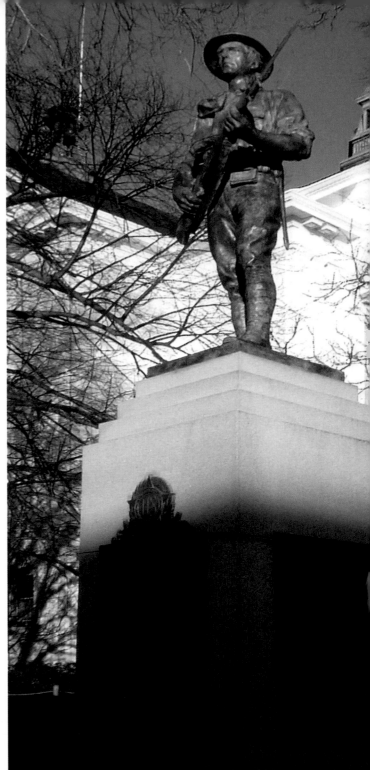

Above: Accommodations range from large hotel chains to cozy B&B's that cater to an individual's preference. During the busy summer season, it can be extremely difficult to get a room without reservations.

Right: The Civil War Monument on Commercial Street is in front of the Town Hall, with Pilgrim Monument in the background.

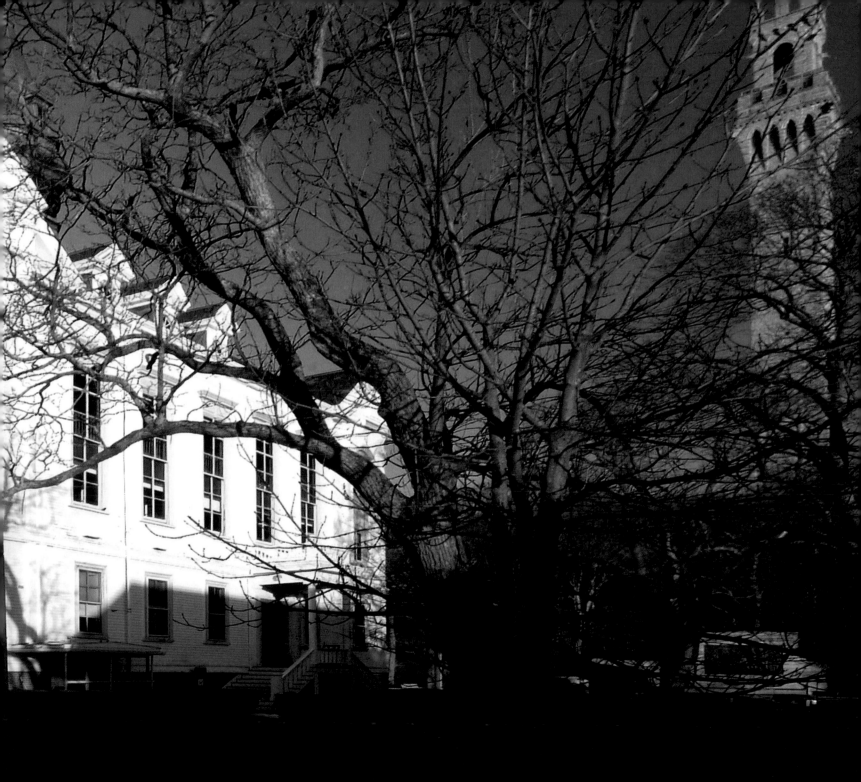

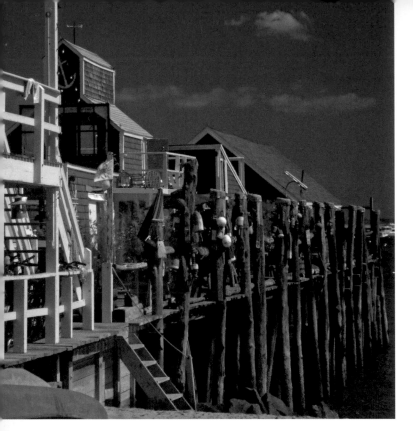

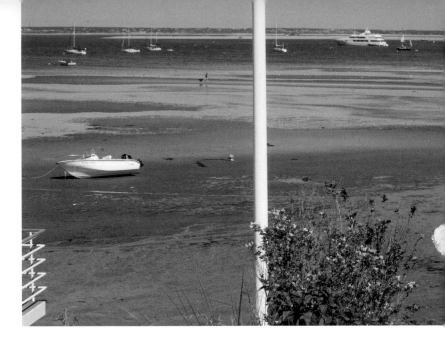

The west end is similar to the east end with homes on the water, marinas, yacht clubs, and rooming houses.

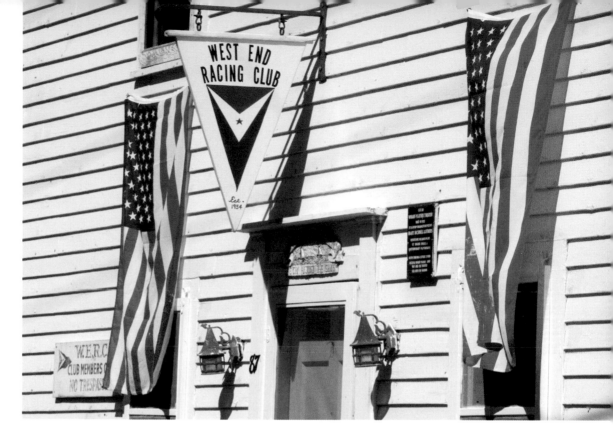

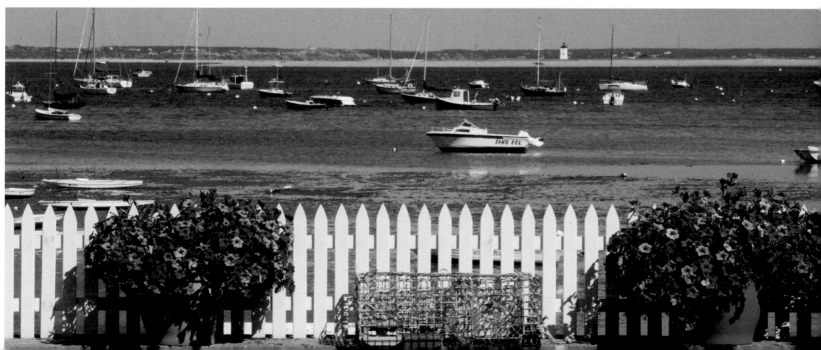

The Harbor

From its beginnings, the harbor has been the central focus of the town, as fishing was the major industry of the natives. Ships designed for whaling, schooners built for fishing, and other vessels could be found docked in this busy, deep-water harbor. Traps set near the shore were tended by small, stable craft that would bring their catch to fish processing plants to be sent to market.

Today the harbor boasts a fleet of whale watching boats that are the finest that can be found anywhere. Some trawlers and draggers still call P'town home, but the number of vessels has declined as fishing stocks have fallen off. Large recreational sailboats and cruisers can be found in slips and moored in the harbor. A variety of craft for sport fishing, sunset cruises, and water activities are available to the visitor. A stroll down Macmillan Wharf allows you to see the diversity of vessels that can be found in Provincetown Harbor.

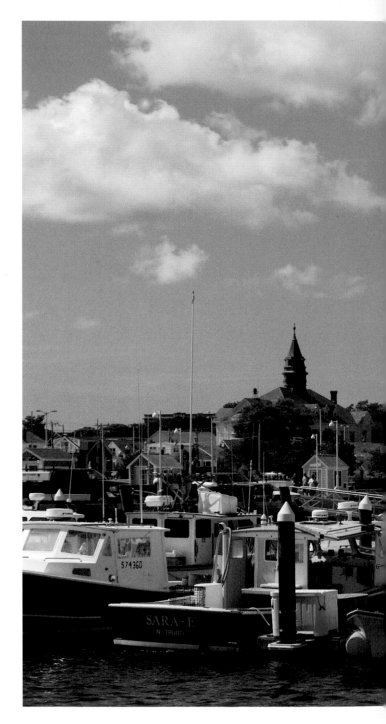

Center: This view of the harbor shows the small fishing boats that can be found in slips. The Pilgrim Monument stands over the harbor on High Pole Hill. The town hall is to the left.

Right: Sailing ships can still be found in the harbor with the occasional visitor making port. In September, schooner races are held offshore.

Left: The working gear of a trawler that drags the ocean bottom for fish.

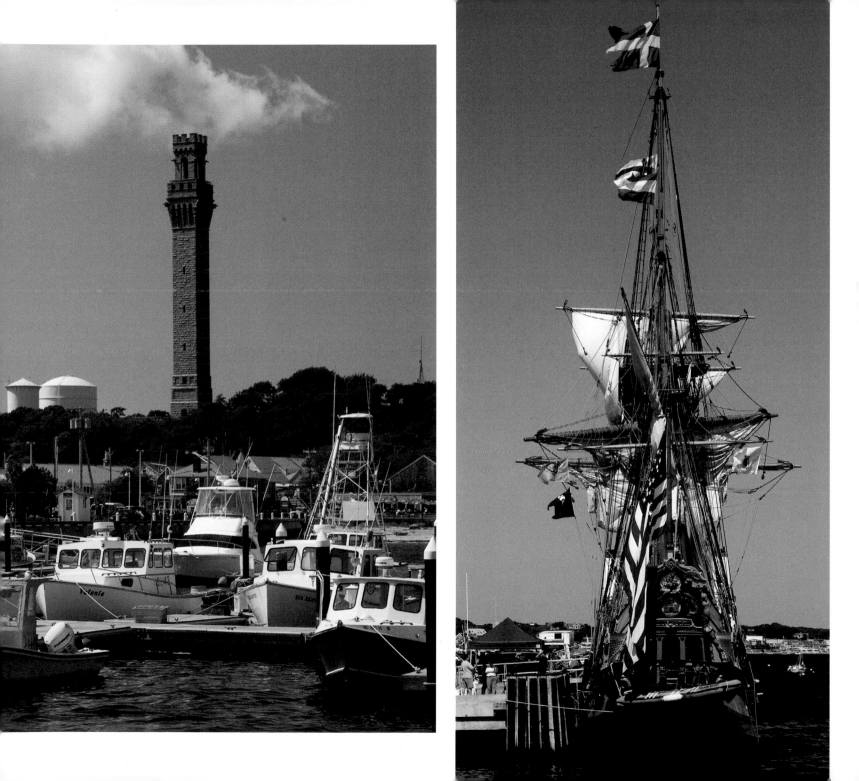

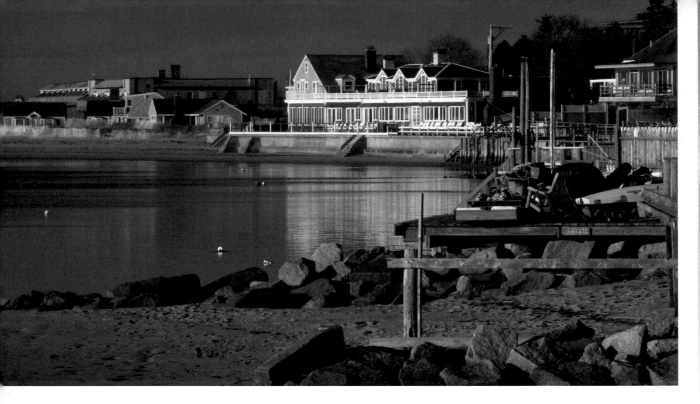

Above: The shore looking towards the west end. Below: Piers extending into the harbor provide additional seaside housing. Right: Marine repair is still available along the harbor.

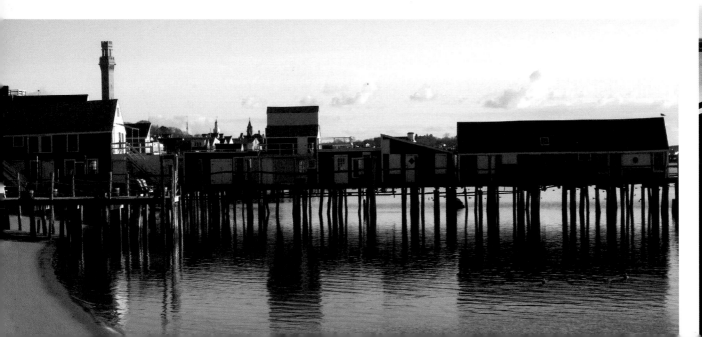

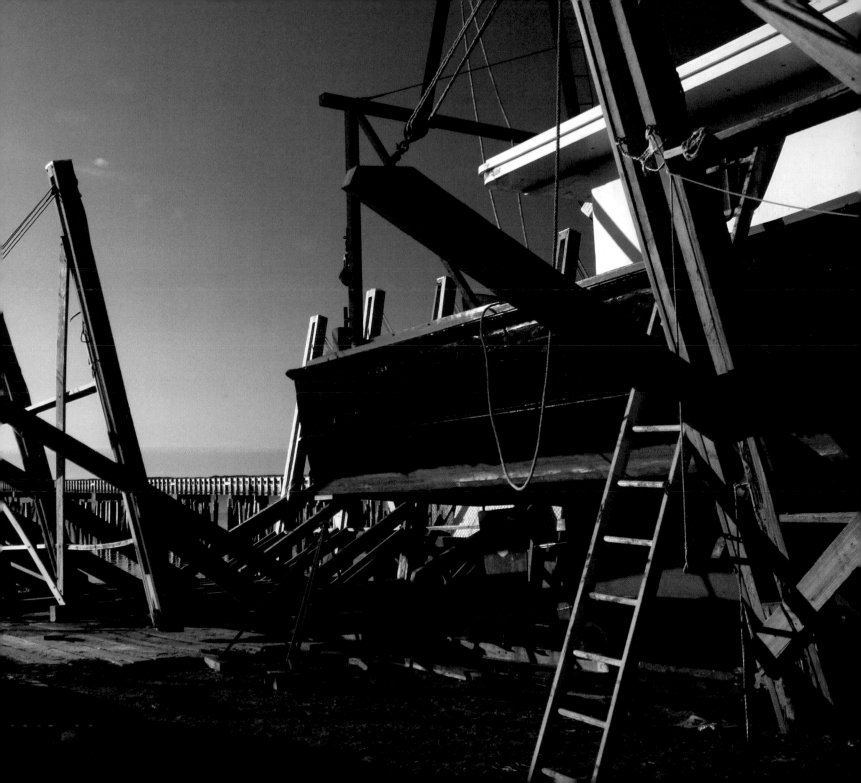

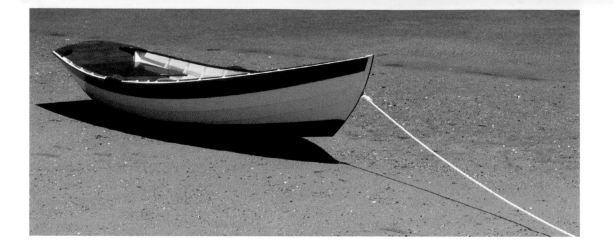

Lobsterpots stacked and ready to go. Fresh caught iced down bluefish heading off to market. Below: Early morning in P'town harbor.

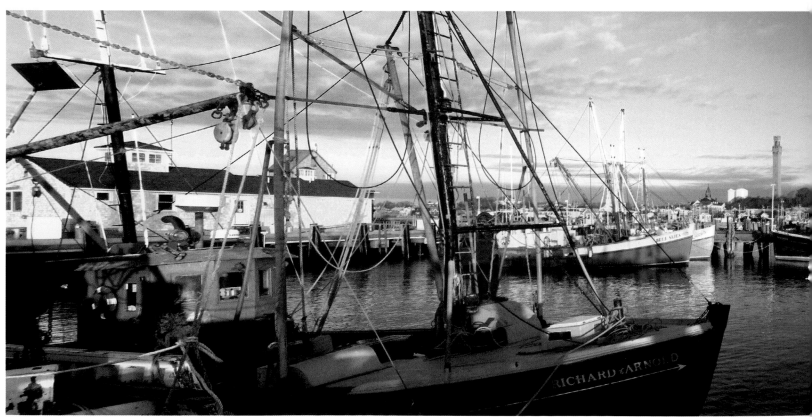

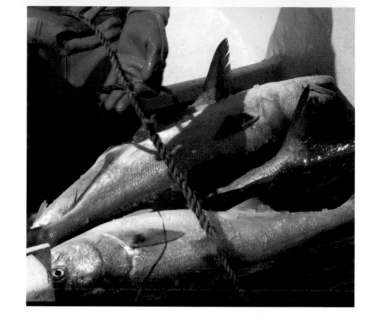

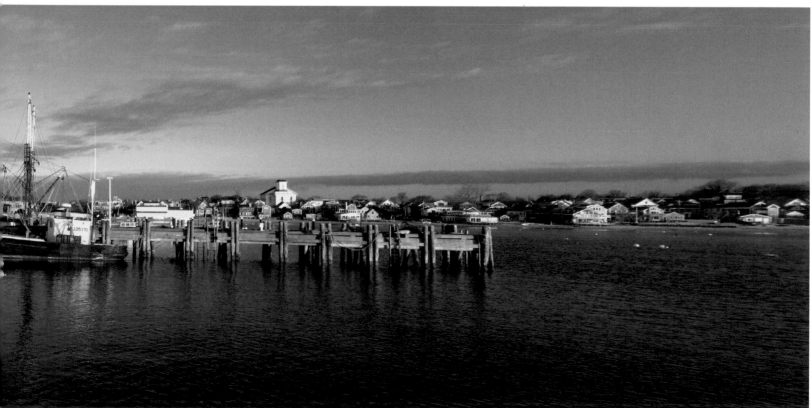

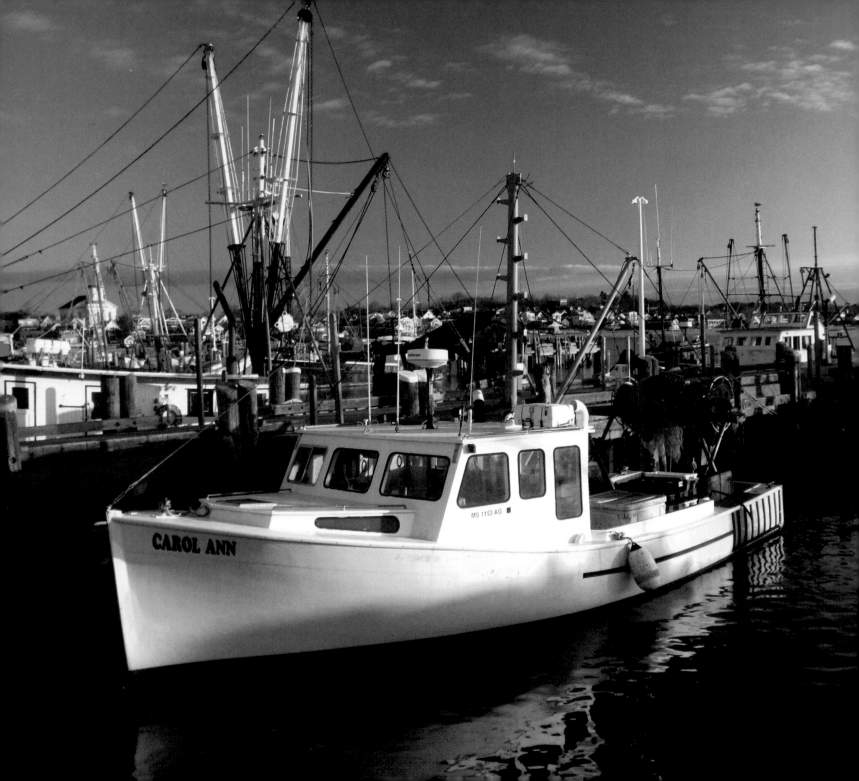

Left: Fishing boats line the dock.

Below: Portraits of fishermen's wives decorate this harbor building.

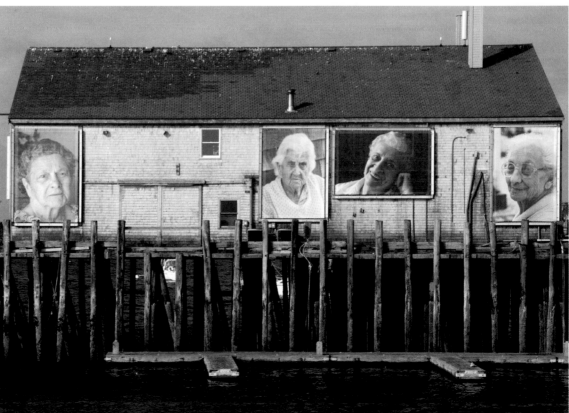

Whale Watching

One of the most popular activities in Provincetown for people of all ages is a trip on a whale watching boat. In the mid-1970s, a fishing charter captain noticed that the fishermen would stop fishing and watch the whales when they were feeding in the same area. An idea was born. In 1975, the Dolphin Fleet started the first whale-watching program to study these magnificent animals and educate the public about whales and their environment. The rest is history, with several fleets visiting the whales from April to October. All trips have naturalists aboard to provide information and education about all marine creatures seen on the trips.

In the past 30 plus years, more than 1300 individual humpbacks have been identified and studied. Other mammals, including dolphins, are frequently seen; marine birds that are rarely seen near land are active when the whales are feeding; and a variety of fish and sharks have been sighted. For 3-4 hours on a nice day, a whale watching trip will provide memories to last a lifetime.

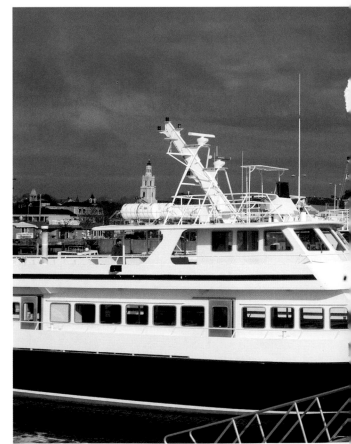

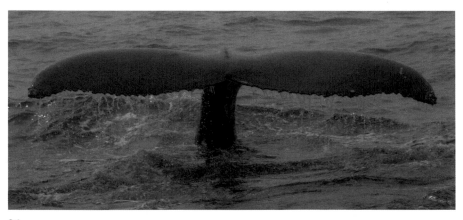

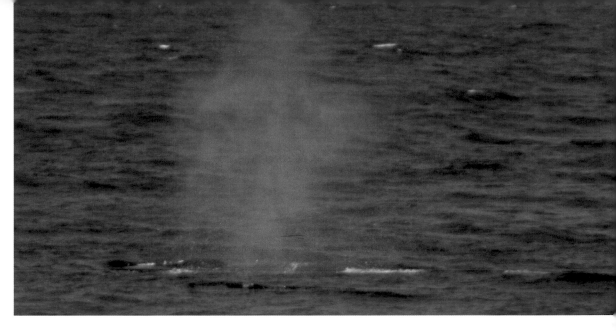

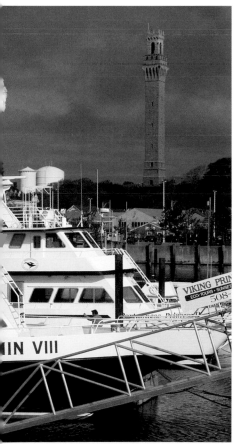

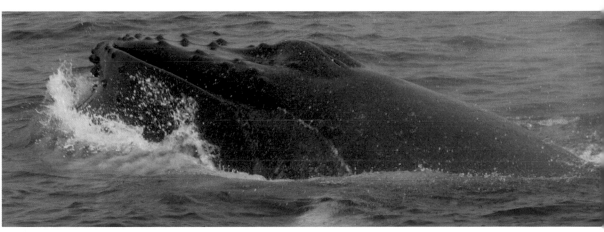

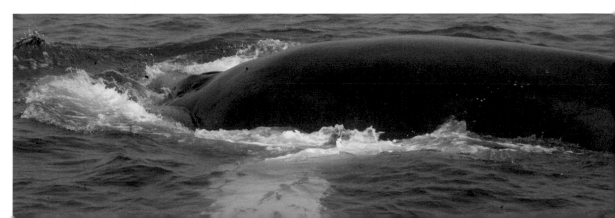

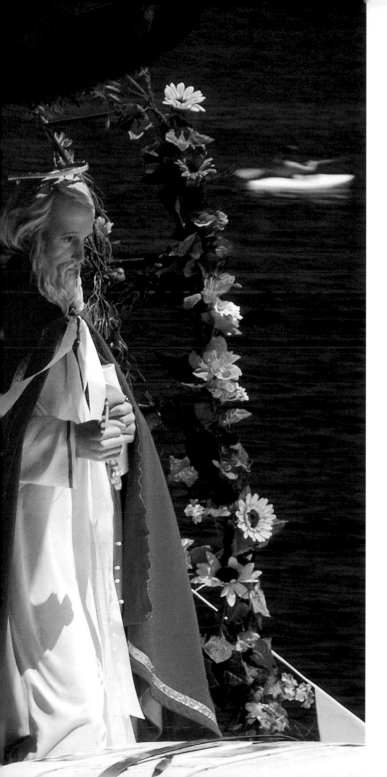

Parades

Parades in Provincetown are an important activity, attracting thousands during the busy summer season. The first celebration of the summer is the weeklong Blessing of the Fleet that culminates on the last Sunday in June with a mass on the dock and a festive procession to the end of Macmillan wharf, where the fishing vessels are blessed by local religious leaders. In addition to honoring its Portuguese ancestry of Blessing the Fleet, which originated in the late 15th century in Portugal for vessels that left on a long and hazardous journey, for over fifty years Provincetown has rejoiced in a variety of events, including band concerts, cultural and nautical traditions.

The Fourth of July, as elsewhere, is celebrated with a daylong celebration involving a number of activities. The highlight in the morning is a parade down Commercial Street that involves numerous dignitaries, and a diversity of floats and exhibits. Fireworks at the end of the day conclude the activities.
In mid-August, the gay and lesbian community has a fun filled week of Carnival that has a Mardi Gras flamboyance with numerous special events. The highlight of the week is the theme-oriented parade down Commercial Street involving dozens of floats in all sizes and shapes. The Carnival Parade is probably the single busiest day in Provincetown.

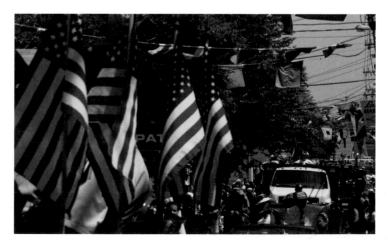

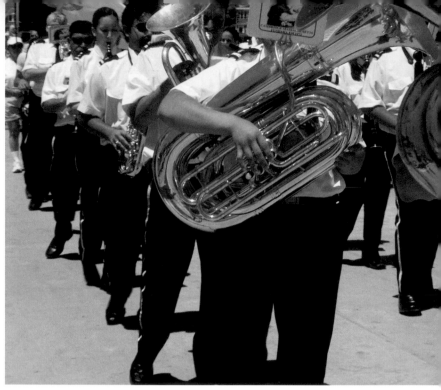

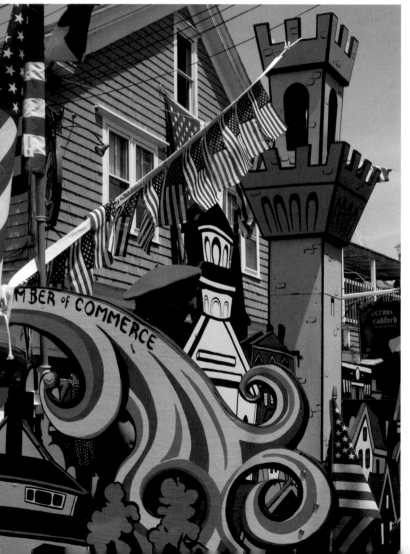

Brightly lit with horns blaring, a fire engine is decorated for the fourth. One of the major attractions in town, the Pilgrim Monument graces a classic float. A large band adds to the ambience of the parade. Dancers in full authentic dress demonstrate traditional Portuguese dances as part of the Blessing of the Fleet

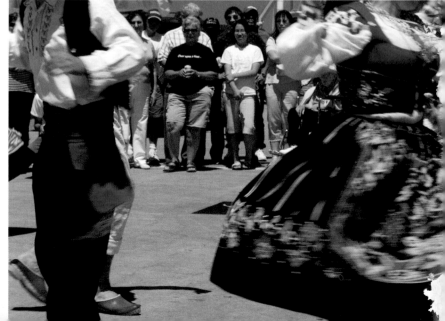

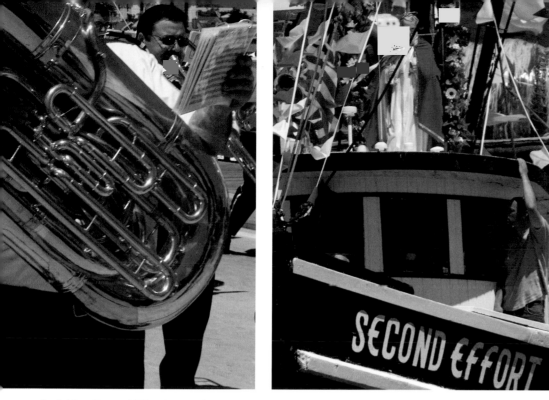

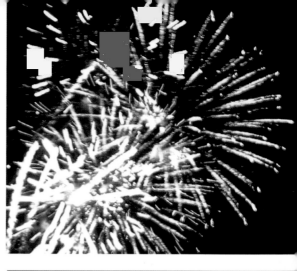

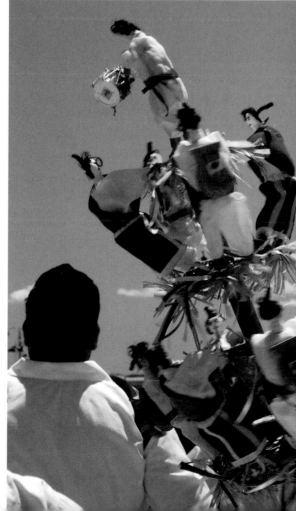

festivities. Second Effort has the honor to lead the parade of fishing vessels. Religious leaders bless the banners of the different vessels. Traditional Portuguese cultural figurines are part of the parade. The culmination of the Fourth of July is a fireworks display in the harbor.

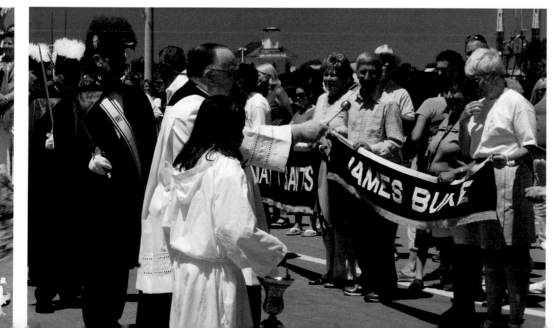

Cape Cod National Seashore

One of the major attractions for visitors to Provincetown is the natural beauty and activities of the Cape Cod National Seashore. Created on August 7, 1961 by President John F. Kennedy, the seashore encompasses almost 44,000 acres from Chatham to P'town and nearly 40 miles of beach and seashore. One of ten national seashores maintained and run by the National Park Service, Cape Cod is unique not only in its geologic history but also for its present landscape of ocean beaches, dunes, marshes woodlands, and freshwater kettle ponds. Numerous activities are available for the visitor, including hiking, biking, bird watching, fishing, and other outdoor activities. There are regularly scheduled ranger-led nature walks, talks, and interactive programs appropriate to the seashore environment. On a day-to-day basis, sightseers and visitors are able to partake in a diversity of programs. The National Seashore is a pristine park that can be enjoyed throughout the year.

Below: This map on display at the visitors center highlights the major areas beaches, and attractions within the Cape Cod National Seashore. Refer to this map as you look at the images in this section. Also, it is possible to see the extent of the national park within P'town. Right: Pilgrim Lake is found mostly in Truro; the parabolic dunes can be seen in the background.

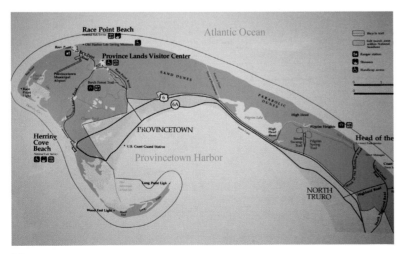

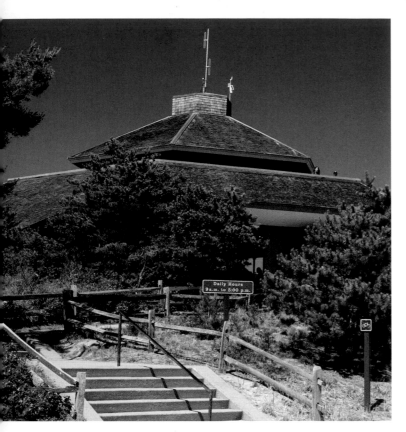

Sitting on one of highest hills in the National Seashore, the visitor center, open from late April to early October, is a must stop to learn to about the area. An observation deck allows 360 degree views.

Bearberry is a delicate ground cover that blooms in late spring with pinkish white flowers. A member of the heath family, it grows in sandy soils and spreads over the dunes.

Another view shows the scrub oak and pitchpine forest with the dunes and beach in the background.

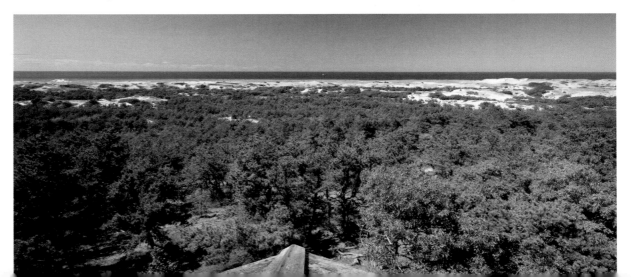

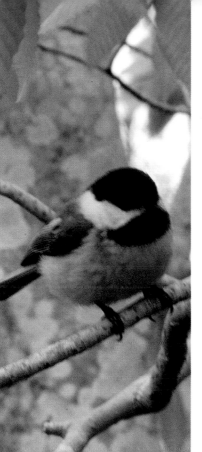

As one slowly walks the trails, many birds are observable, such as this black- capped chickadee. Built in the late 1960's and the first bike trail ever developed in a national park or seashore, Provincelands Bike offers miles of trails that wind through forests, dunes, and beaches.

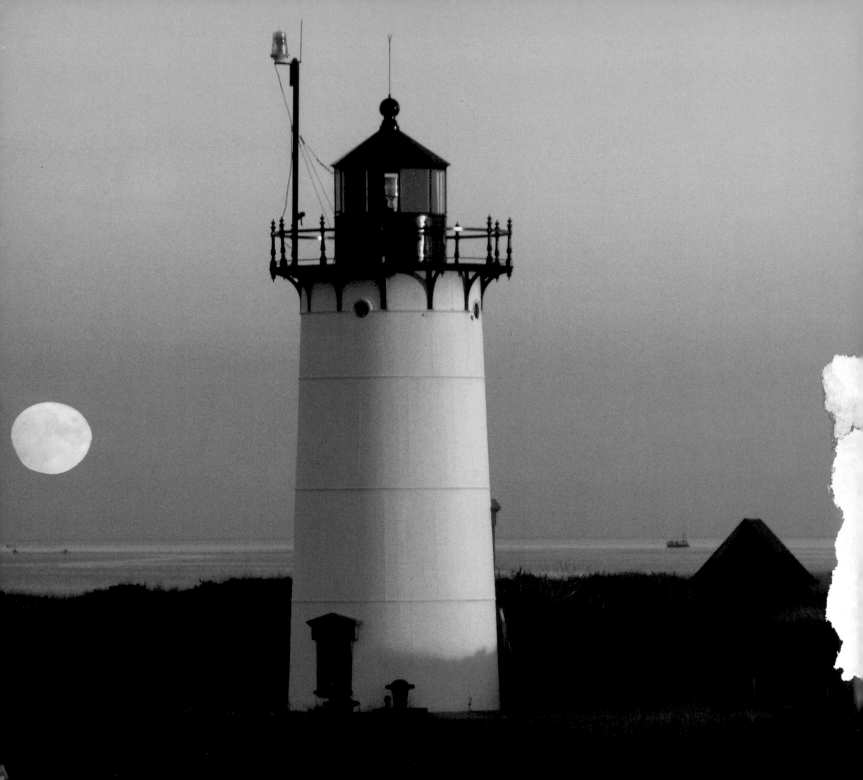

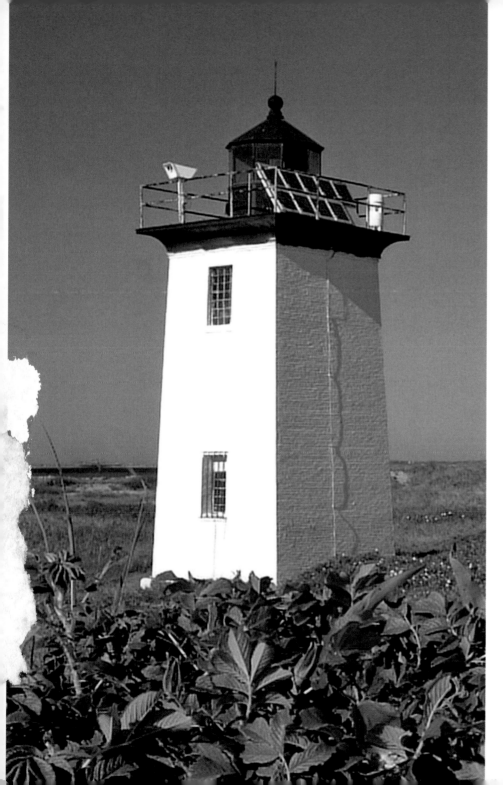

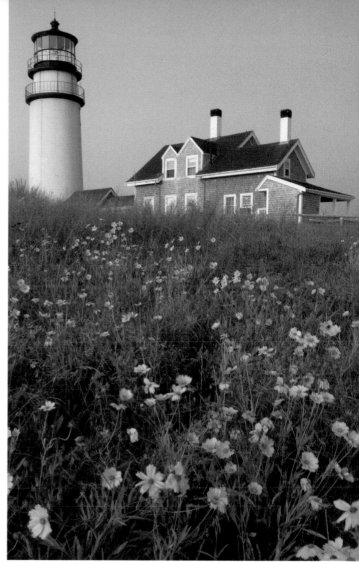

Far left: Moonrise at Race Point Light. Race point Light is available for overnight stays in the keeper's house and whistle building on the right.

Near left: Still an active aid to navigation, Long Point Light sits at the end of the spit of land forming Provincetown Harbor. A whale watch boat can be seen in the background.

Above: Highland Light in Truro is the tallest beacon on Cape Cod and can be seen from many locations in P'town.

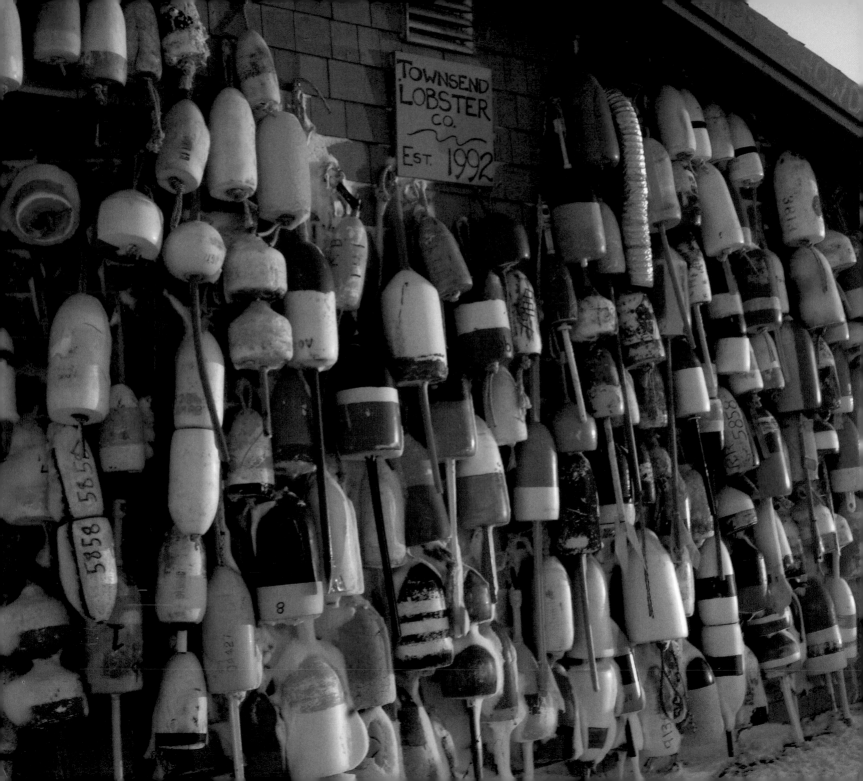

Winter Medley

The summer is obviously the busiest season in P'Town, but spring and fall attract visitors for the nature and ambience of the locale. Winter also holds a special attraction for many, as more stores and restaurants are open for the holiday season. Covered in snow, the local vistas offer a view few can imagine in the summer. There may not be as many sightseers to the area in winter, but there is no lack of beauty and charm for the visitor to experience.

Left: Lobster pots hang on the wall of a fish market near the harbor.
Below: Just before sunset, the three distinctive landmarks of Pilgrim Monument, town Hall and the Universalist Meeting House are characteristic against the sky.

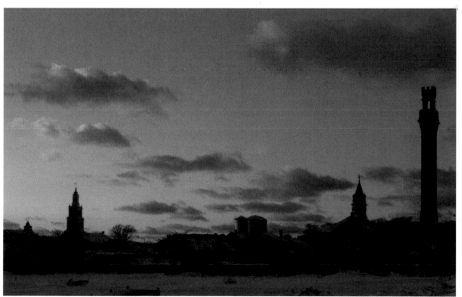

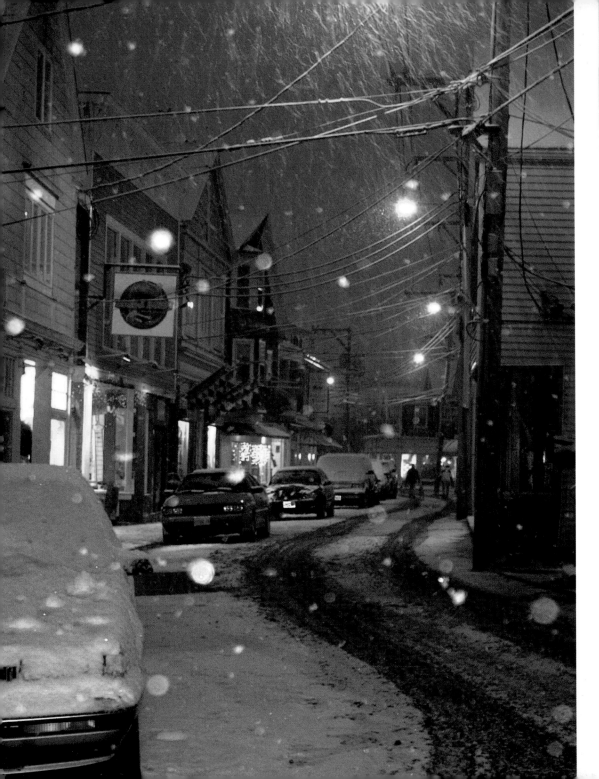

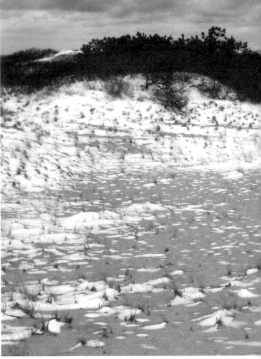

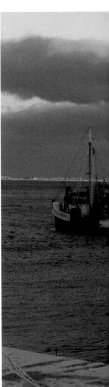

Left: Commercial Street during a snowstorm. Above: The dunes in winter offer a bleak attraction to bike or hike. Right: The harbor in winter has fewer boats, and many of the docks have been removed.

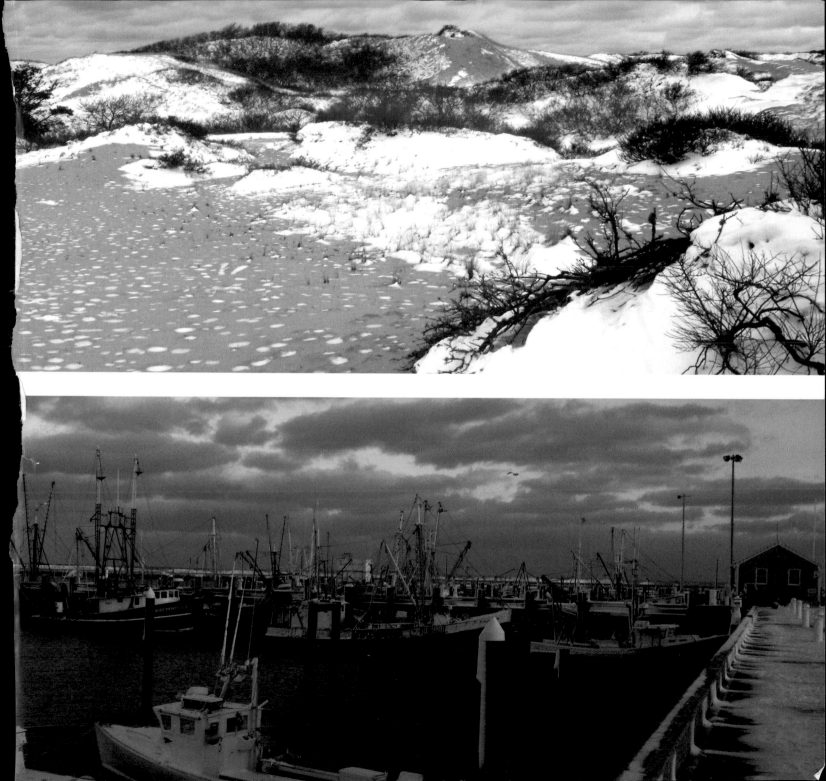

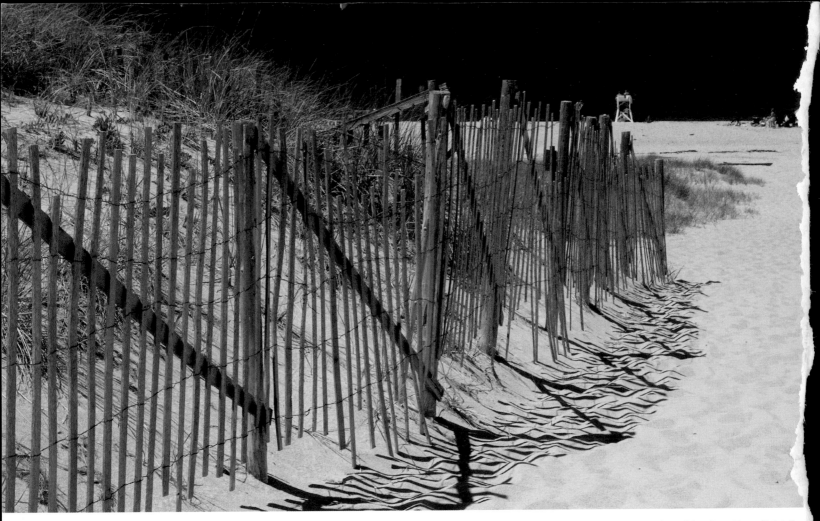

A beach trail leads to Race Point Bea

Arthur P. Richmond is a retired science educator who has been involved in photography for over 45 years. Starting his photo career working for a newspaper while in high school, h has provided images for textbooks, magazines, and other publications that include postcards, calendars, and travel books. The author and photographer of the highly acclaimed panoramic Wide Seri that includes *Cape Cod Wide* and *No Shore Wide*, he has published seven bo to date. His images are displayed and sho on Cape Cod and at several galleries. I work can be viewed and he can be reach at www.capecodwide.com, where imag are available for purchase.